Rembrandt

This one is for Solomon

— With love

Shelley Rohde

REMBRANDT
An A to Z

THOTH Publishers, Bussum

Museum Het Rembrandthuis, Amsterdam

Amsterdam

Self-portrait, c. 1628

Oil on panel
Rijksmuseum, Amsterdam

Portrait of the artist as a
young man – looking every
inch the beardless boy that
Huygens called him.

Jacob Blessing the Sons of Joseph, 1656 (detail)

Oil on canvas
Gemäldegalerie, Kassel

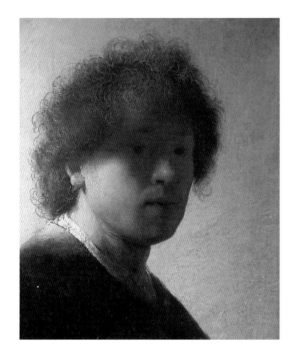

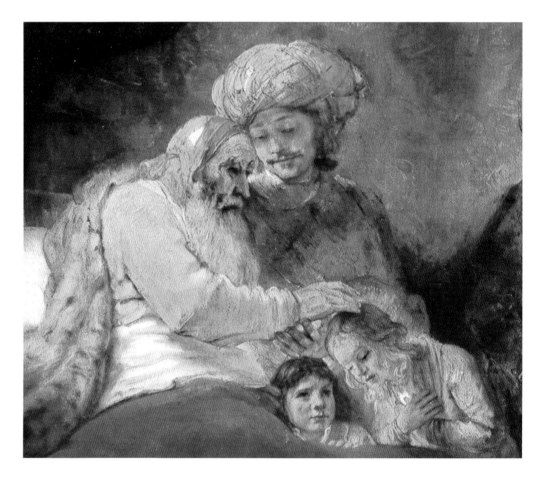

To say that Rembrandt Harmenszoon van Rijn was a great artist is not enough. He was more than that. He was an extraordinary painter, a fine draughtsman and an etcher of international fame in his lifetime. And, he was probably the greatest story teller in the history of art. This was his gift. This was his genius. He knew how to make his pictures talk. He gave them life. He gave them humanity.

Rembrandt Harmenszoon van Rijn was born on 15 July, 1606, in the heroic town of Leiden, lately held to siege by warring Spaniards. These were tumultuous times. Long years of war between the Northern Provinces of the Netherlands and Catholic Spain were lurching to an uneasy close.

Even as a boy Rembrandt was special. He was the only one of the ten children born to a miller and his wife to be given a classical education. Not that he was much taken with conventional learning. According to a contemporary history of the city, by the time he was 14 he had decided he must leave the Latin School where he had been since he was seven. 'His only natural inclination was for painting and drawing,

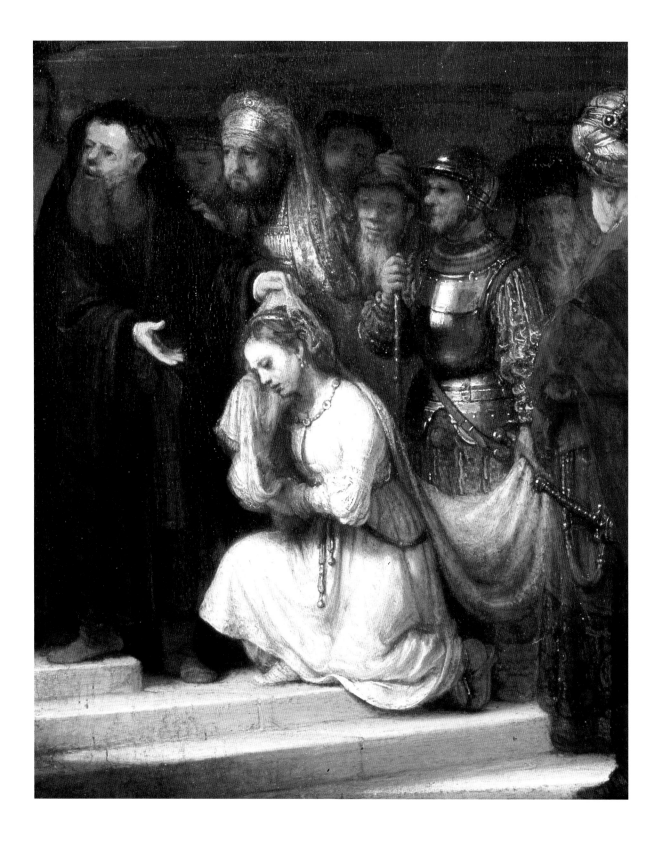

Christ and the Adulterous Woman, 1644 (detail)

Oil on panel
National Gallery, London

So much emotion. So much tenderness. In this painting, as in the faces of the father and his son on the previous page.

so that his parents were compelled to take him out of the School, and following his own wishes to apprentice him with a Painter where he might learn the foundation and principles of art.'

The local artist to whom they sent the boy was, by all accounts, distinctly mediocre. But for three years, while the town went to the brink of civil war, he schooled his apprentice in the basic skills of his craft, making brushes with the tail hair of squirrels or developing colour from things such as sulphur and vinegar warmed with piles of steaming horse manure.

In the beginning, when he had yet to choose a name to make, Rembrandt signed his pictures RHL: *Rembrandt Harmenszoon of Leiden*. Occasionally he might write *Rembrandt van Rijn* (Rembrandt of the Rhine), sometimes with the 'd',

sometimes without. It was an unusual name even then. It gave him distinction. It still does. There is only one Rembrandt, with or without the 'd'.

As his confidence grew, he started to mark his work with a single name – in the manner of the masters of the Italian Renaissance. This was done less in arrogance, more in pride. He had a deep sense of calling. A seventeenth century Italian called him a 'most capricious man', while a contemporary Dutch poet described him as 'the greatest heretic in art'. But that was after he was dead and beyond caring. Not that he ever really cared what people thought – or, if he did, he didn't care enough to change the way he lived, the women he loved or the pictures he painted.

In other words, he was never a conformist. All his life he marched to a different drum. By the time he was twenty-five

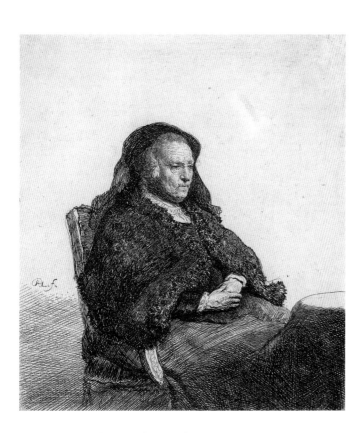

***Rembrandt's Mother Seated at a Table*, c. 1631**

Etching
Rembrandthuis, Amsterdam

Most scholars believe that Rembrandt's mother, Neeltge van Suydtbroeck, was the model for this etching. At a distance of 400 years it is impossible to be sure.

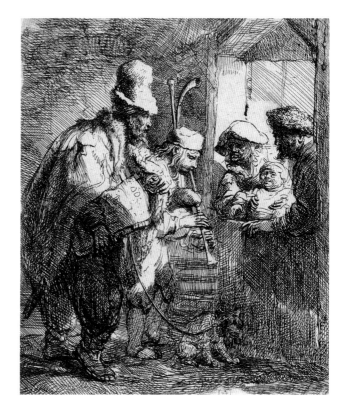

***Strolling Musicians*, c. 1635**

Etching
Rembrandthuis, Amsterdam

The streets of seventeenth century Amsterdam teemed with colourful characters that could not fail to catch the eye of the young artist newly arrived in the city.

it had become clear that Leiden could contain him no longer. For six years he had been a free master there, an independent painter with a growing reputation. Now he needed more, much more.

This was a golden age and Amsterdam, in the seventeenth century, was the very place to be. It was here that names and reputations and fortunes were to be made. Known for political and religious tolerance unique in Europe at the time, Amsterdam was exciting, exhilarating, cultured, elegant, prosperous and constantly stimulating. Everywhere the *chiaroscuro* of a cosmopolitan community assailed the eye and ear.

Rembrandt, a shock-haired dynamo in love with art, had already been to the great city. He had spent six formative months there when he was just 18, travelling by boat through flat fields and still water, to study with Pieter Lastman, a solid Dutch painter and fine teacher. Now he came again to Amsterdam, to join the studio of Hendrick Uylenburgh, dealer in art and member of the prestigious Guild of St. Luke and thus well placed to introduce a fledgling artist into lucrative company. *La famosa accademia di Eulenborg,* as someone called it.

This was 1631, the year in which the French philosopher René Descartes, a man so rich and gifted he could have lived anywhere, wrote of Holland: 'What other country could one choose where all the conveniences of life and all the exotic things one could desire are to be found as easily? Where else could one enjoy a freedom so complete?'

This was the year in which Rembrandt van Rijn came to Amsterdam, there to live out his life and there to die.

The Blind Fiddler, 1631

Etching
Rembrandthuis,
Amsterdam
↙

The Omval, 1645

Etching and drypoint
Rembrandthuis,
Amsterdam
↙↙

The Omval, 1645 (**detail**)

Etching and drypoint
Rembrandthuis,
Amsterdam
↓

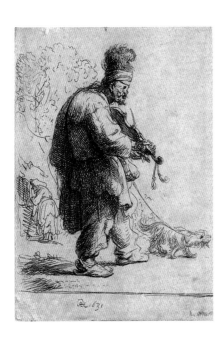

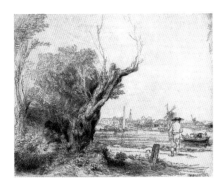

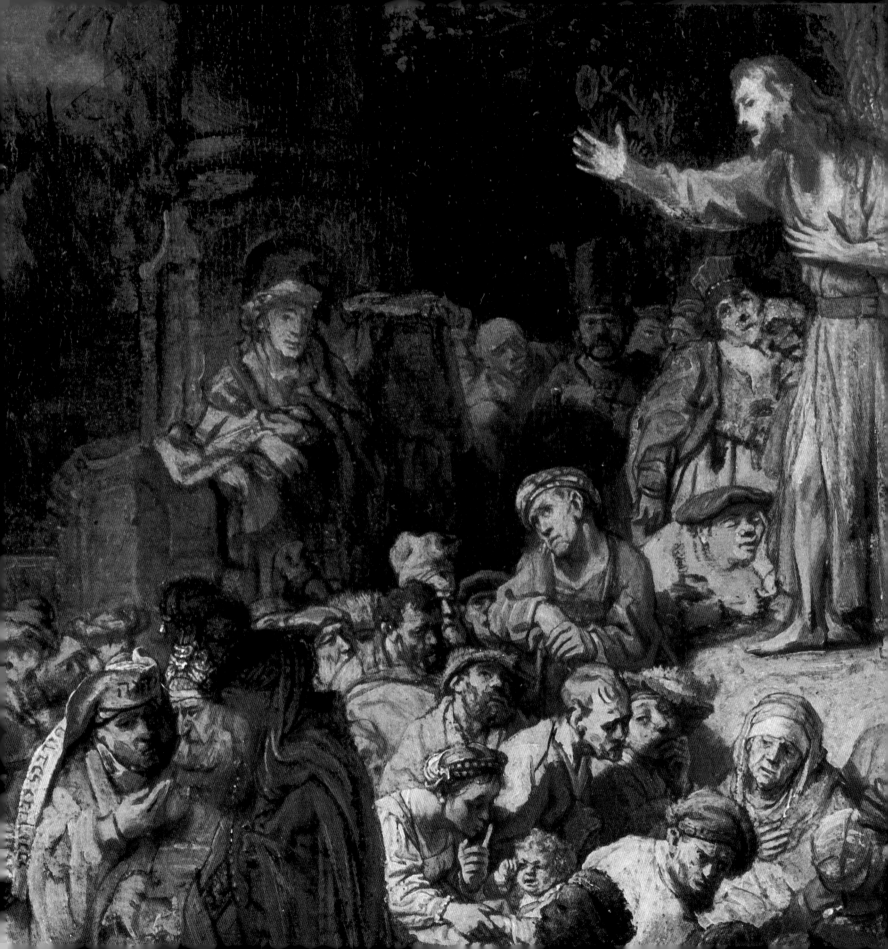

Bible

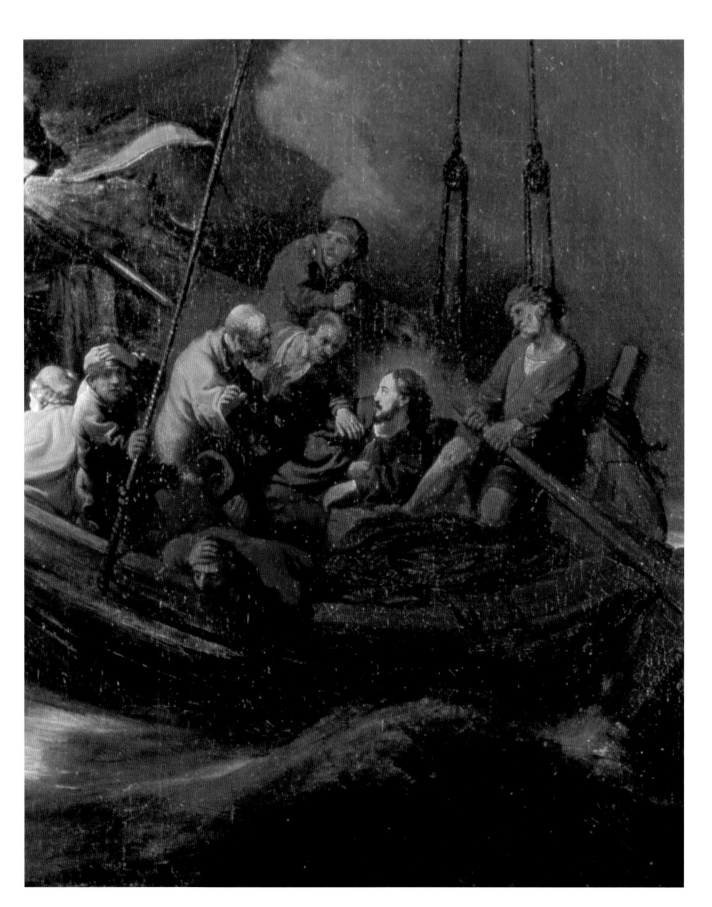

***Christ in the Storm on
the Sea of Galilee**, 1633
(detail)*

Oil on canvas
Isabella Stewart Gardner
Museum, Boston

A typical piece of
Rembrandt theatre – a
disciple vomits over the
side of the boat.

Someone once said of Shakespeare (and this was his time) that he had the gift to see the ordinary in the midst of the extraordinary. This was Rembrandt. Exactly. Shakespeare did it with words, Rembrandt did it with pictures. He had an eye for the prosaic, the mundane, the everyday scene from life that, in his hands, became remarkable: the human detail that made a story live. And if, along the way, the irreverent touch he added to a work seemed just a shade profane, then so be it. That was the way he saw life and that was the way he would

St. John the Baptist Preaching,
c. 1634

Oil on canvas glued to panel
Gemäldegalerie, Berlin

The great man speaks and everyone listens. Except in a Rembrandt picture. Here, of course, human life goes on: old men debate, dogs misbehave and a mother shushes her child.

The Good Samaritan, **1633**

Etching and burin
Rembrandthuis, Amsterdam
↗

The Good Samaritan, **1633 (detail)**

Etching and burin
Rembrandthuis, Amsterdam

An irreverent touch too far. Once again Rembrandt shocked the righteous.
→

13

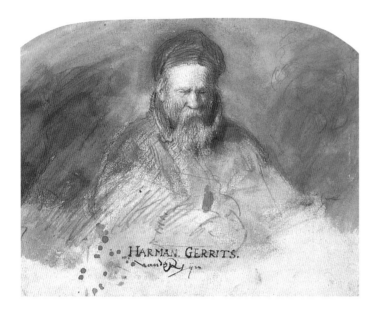

HARMAN. GERRITS.

Portrait of an Old Man, c. 1630

Drawing in chalk
Ashmolean Museum, Oxford

Believed to be Rembrandt's
father, although the inscription
Harmen Gerritsz is written in
another hand.

Christ Preaching (La Petite Tombe), c. 1652

Etching, burin and drypoint
Rembrandthuis, Amsterdam

Jesus Christ might be preaching
to an attentive crowd, but to a
child a piece of string is far
more interesting.
→

show it: a man pissing in the street, a dog defecating, a monk fornicating in a cornfield...

For Rembrandt, religious paintings were no exception. He saw no reason to treat a holy story with undue reverence. The Bible was life like any other. It was hardly surprising, then, that such reality injected into tales of rectitude and righteousness caused more than a few raised eyebrows. His etching of *The Good Samaritan*, the parable of a man who went to the aid of the victim of a roadside mugging, is a particular case in point. The central figure, in the foreground of the picture is neither the injured man nor the Samaritan. It is a dog enthusiastically emptying its bowels.

The puritans saw only indecency, profanity and vulgarity, not the fact that it was these very touches of normality that gave Rembrandt's pictures truth. One critic, a former student, discovered a pair of dogs doing something unacceptable in a picture of *St. John the Baptist Preaching* and decided that this only served to demonstrate Rembrandt's 'despicable lack of taste'. How could a scene from the Bible, he asked, 'fulfil its all-important function of edifying if it is indecent, immoral and irreverent?'

Rembrandt's response can only be imagined. Curiously, no such badly behaved dogs can be seen in the picture he named.

It had been inevitable, somehow, that the young Rembrandt should have begun his career making pictures with a religious theme. In Leiden in the early seventeenth century, religious conflict was as much a part of life as the air he breathed. When he was a boy sentence of death for what was seen as offences against religion were far from rare. A Prime Minister of the day had his head chopped off in public, virtually for being too tolerant. And a leading intellectual, a humanist in the contemporary sense of the word, was also condemned to death but killed himself before sentence could be executed. Such was the strength of feeling on the part of the authorities that his dead body was sent to the gallows where it hung in its coffin, beside the disembowelled remains of thieves and murderers. Rich history for a boy of twelve.

One mystery (among many in Rembrandt's life) has puzzled historians for years: which religion did Rembrandt himself embrace? His mother, Neeltge van Suydtbroeck, was deeply religious, a Roman Catholic who held to her faith all her life. His father, Harmen Gerritszoon van Rijn, was a practising member of the Dutch Reformed Church, the religion in which the young Rembrandt was raised. Throughout his life Rembrandt worked with men and women of all denominations. He showed preference for none above the

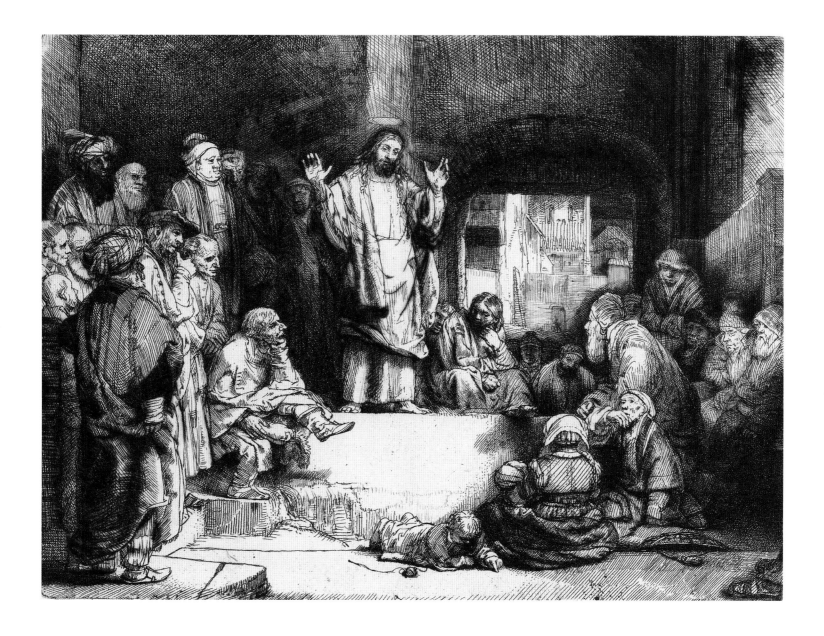

other. It is a riddle that remains unsolved and, at a distance of four hundred years, is likely to remain so.

His pictures offer no solution. He painted scenes from the Old Testament and the New. He painted Jews and Philistines, saints and sinners, Christian preachers and heroes of classical mythology. He painted bad men and good women and vice versa. And, besides, as one scholar puts it: *content should not be confused with belief*. In other words, a Rembrandt painting of his son in the habit of a monk does not mean he wanted the boy to take holy orders, any more than a portrait by Rembrandt of Rembrandt wearing armour makes him a soldier.

If this is true of any artist it is especially true of Rembrandt. He was a man of many guises.

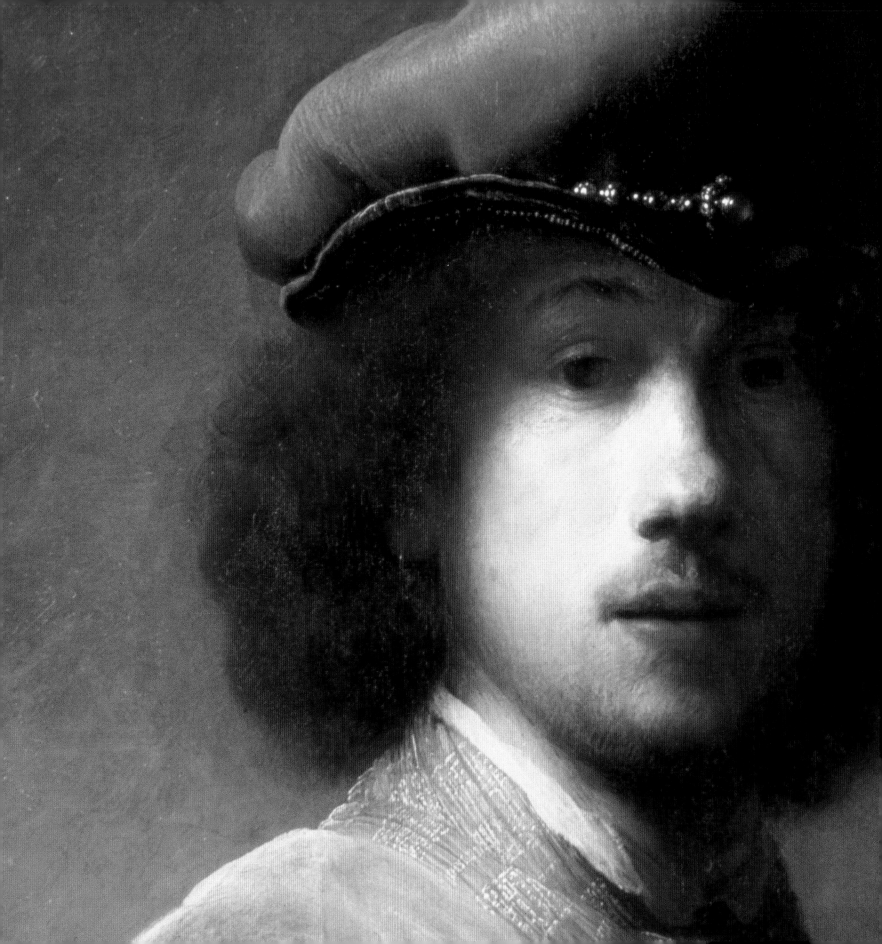

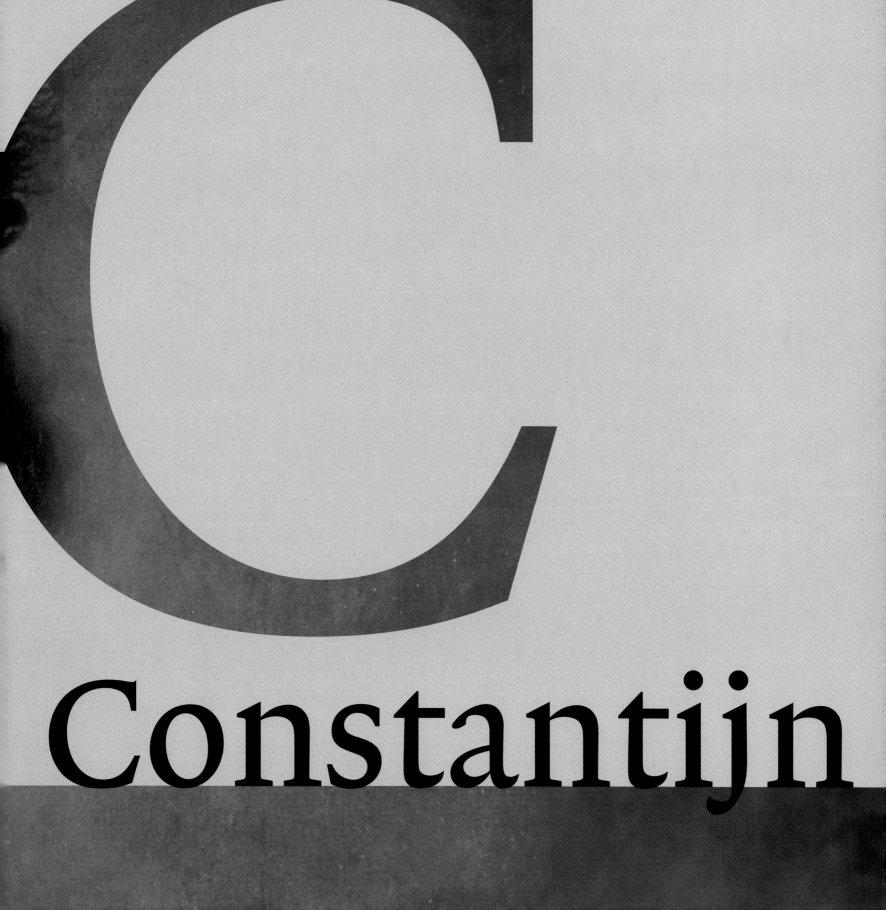

Constantijn

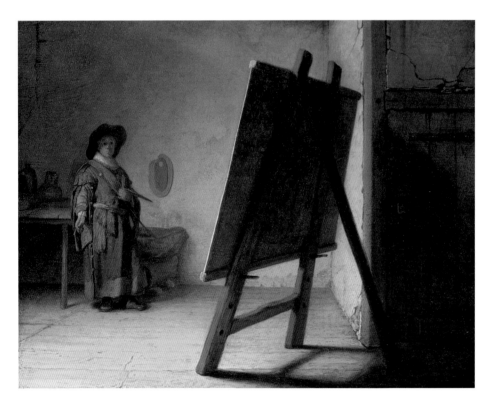

For Rembrandt recognition came early. When he first caught the eye of a latter day talent scout from the Dutch court, he was just twenty-two years old, a chubby man with a putty nose and the 'frame and face of a boy'.

This was the era of the art lover, a time when gentlemen were avid in the pursuit of cultural and intellectual excellence. Constantijn Huygens was every inch the art lover. A true connoisseur, or what in seventeenth century Holland was known as a *kenner*. A man who knew a good thing when he saw one. He was a secretary to the Prince of Orange, Frederick Hendrick, and it was his job, or part of it, to seek out artists who might bring lustre to the royal court.

One of the first among his discoveries was Rembrandt van Rijn, just beginning to make a name for himself in Leiden, the walled city of windmills and canals, home to the first university in Holland. It was in 1628 that Huygens came to Leiden and there met with Rembrandt and his friend, the even younger prodigy Jan Lievens, whom Constantijn decided were 'miracles of talent'.

Constantijn was ten years older than Rembrandt, a dapper young man, with piercing dark eyes and a sharp face made the sharper by the neat pointed beard he wore in the style of the artist Van Dyck. He was widely travelled, spoke many languages, had studied physics, astronomy, theology, architecture, music and painting. He corresponded in three languages with the French philosopher Descartes and when he came to write his own life story, he wrote it in idiosyncratic Latin.

His was an elite society, an intellectual world, so that when he chanced upon Rembrandt and Jan, in their provincial studio with its bare boards and crumbling plaster, he could not hide his astonishment: 'The name of the first one, who I have called the embroiderer's son, is Jan Lievens; the second, who comes from a miller's family is Rembrandt – both beardless, with the frames and faces of boys rather than

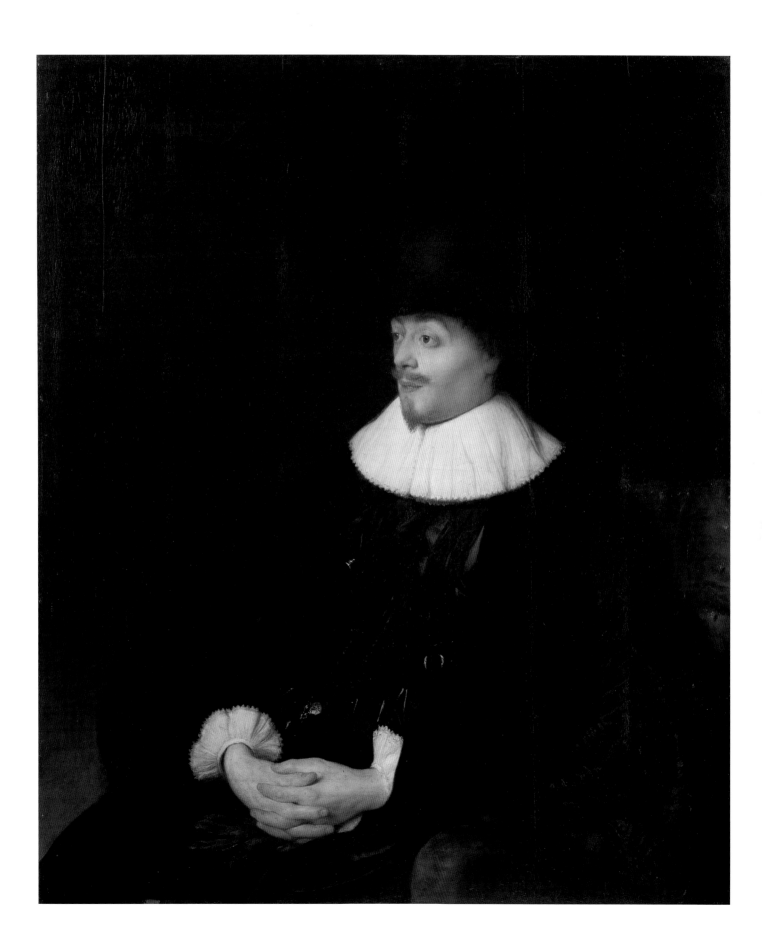

Music-making Company, 1626

Oil on panel
Rijksmuseum, Amsterdam

The harpist standing at the back is
thought by some to be strongly
reminiscent of Lievens with his
pointy chin and long nose – others
believe it to be Rembrandt himself.
It is a popular game – spotting the
cast of Rembrandt's life in his works.

young men. Who could fail to be amazed to see such miracles of talent and ability produced by such everyday instruments.'

Lievens had already lobbied to paint a portrait of Constantijn, which may have been what brought the great man to Leiden. Friends from childhood, it seems that Lievens and Rembrandt had been in competition all their working lives. Rembrandt had gone to Pieter Lastman when he was 17 or 18; Lievens when he was ten. Now they were both back in Leiden and painting like men possessed.

In Leiden at this time, popular opinion marked Rembrandt as the lesser of the two. Huygens was not so sure: 'Rembrandt is superior to Lievens in judgement and in the liveliness of emotion. Lievens surpasses him in the loftiness of his concepts and the boldness of his subjects and forms (...). Rembrandt (...) devotes all his loving care and concentration to small painting, achieving on a small scale a result that one would search for in vain in the larger works of others.'

It was not long before Rembrandt achieved a real coup. He was commissioned to do a series of paintings from the Passion of Christ for the Prince of Orange. This was seriously good news. The fees paid by royalty were far greater than anything an artist might expect in Leiden; and, besides, think of the honour.

Despite this, it was to be nearly ten years before Rembrandt completed the Passion series and when, finally, it was done, the paintings were not universally admired. Huygens may have been looking for reflected glory from the work of his protégé for when it was not forthcoming, the relationship cooled. Rembrandt, never the conformist, had done his own thing, his own way.

A few months later Rembrandt sent Huygens a token 'thank you', generally believed to be the monumental work *The Blinding of Samson*. Huygens wanted none of it – not that Rembrandt took any notice of that. 'Because I wish to do this,' he wrote in January, 1639, 'I am sending this accompanying canvas, against my lord's wishes, hoping that you will not take me amiss.'

Some years later, after Frederick Hendrick's death, the Prince's widow required Huygens to suggest artists who might make pictures for the royal palace she was creating as a memorial to her late husband. Fourteen artists were invited to contribute. Lievens was one of them. Rembrandt was not.

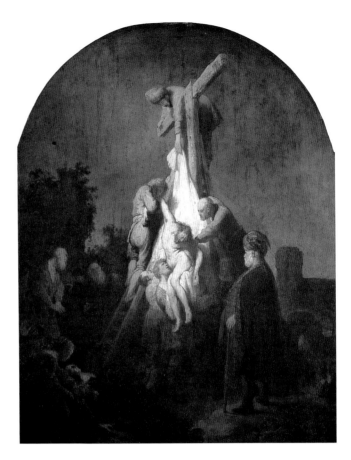

Descent from the Cross, c. 1633

Oil on panel
Alte Pinakothek, Munich

One of the dramatic scenes from the Passion of Christ that Rembrandt painted for the Prince of Orange, Frederick Hendrick. They were not universally admired.

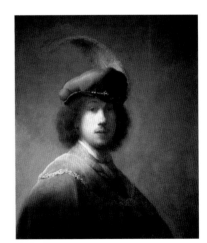

Self-portrait in a Plumed Hat, 1629

Oil on panel
Isabella Stewart Gardner Museum, Boston

A man of many guises, on occasion Rembrandt portrayed himself as an elegant young buck.

Dramatis Personae

The fact that Rembrandt had not one but two mirrors in his house, at a time when such things were something of a luxury, had nothing to do with vanity. Or extravagance. They were the tools of his trade.

He used them to watch himself making faces and to capture his expression on canvas – astonished, angry, happy, sad, frowning, scowling, mouth open, mouth closed, bare headed, with armour and without, wearing fancy hats or rich robes or the golden helmet of a great warrior.

It was his way of learning how to communicate emotion. It was part of what made him a master story teller. Or as one important Rembrandt expert puts it: *a great stage director.* The characters that peopled his pictures were real. They were from life. His life. And so, when the young Rembrandt started making pictures of tales from history or from the Bible, he would frequently use his own face when he wanted to show ordinary people involved in extraordinary events.

Over the centuries it has become a favourite game for art students: spotting the artist's face in his work. In one of the earliest Rembrandt paintings the young artist has a walk-on part as a liveried attendant. It is called simply *History Piece,* and in it he looks every bit the beardless boy that Huygens called him. He is a shocked spectator, gawping at the miracle

of resurrection in *The Raising of Lazarus*, an etching done when he was 26. In *The Return of the Prodigal Son* he is a servant peering from a window, and a face in the crowd in *The Stoning of St. Stephen*. Someone has even decided that he makes a guest appearance in his most famous painting, *The Night Watch*. Or rather, just his eye can be seen (or so they say) peering out from behind the heads of the fee-paying cast.

An eighteenth century biographer, who had spoken to people who knew the artists he was writing about, described Rembrandt's 'heedful reflections on all manner of passions'. And Samuel van Hoogstraten, one of Rembrandt's pupils who later wrote a 'how-to' book about painting in which he passed on much of what he had been taught by his old teacher: 'You will benefit from depicting your passions as you see them before you, especially before a mirror, where you are at once subject and beholder…thus one must reshape oneself entirely into an actor.'

The use of a good-sized looking glass was so important to Rembrandt that, in May 1658 when he was beset by money troubles, he sent his son Titus to redeem a fine mirror framed in ebony. It had gone some time before to a pawnbroker, several streets away on the other side of a canal, in exchange for the loan of cash. Titus duly collected the mirror and,

Self-portrait, looking angry, 1630

Etching
Rembrandthuis, Amsterdam

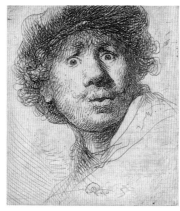

Self-portrait, looking amazed, 1630

Etching
Rembrandthuis, Amsterdam

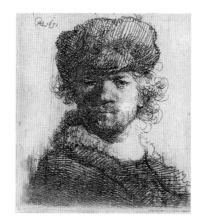

Self-portrait in a Fur Cap, 1631

Etching
Rembrandthuis, Amsterdam

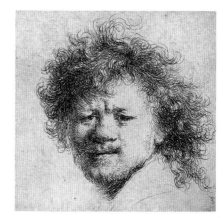

Self-portrait with Bushy Hair, c. 1631

Etching
Rembrandthuis, Amsterdam

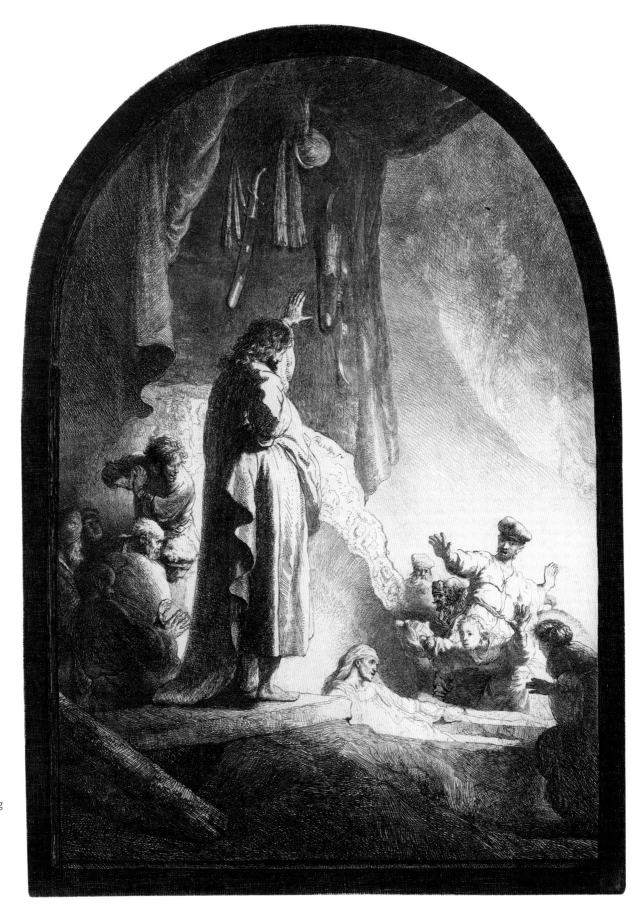

The Raising of Lazarus, c. 1632

Etching and burin
Rembrandthuis, Amsterdam

Ever the observer at great
moments in history, the young
Rembrandt stares in wonder
at Lazarus resurrected.

25

The Night Watch, 1642 **(detail)**

Oil on canvas
Rijksmuseum, Amsterdam

And could this be Rembrandt's
eye, half hidden by the press of
the fee-paying cast?

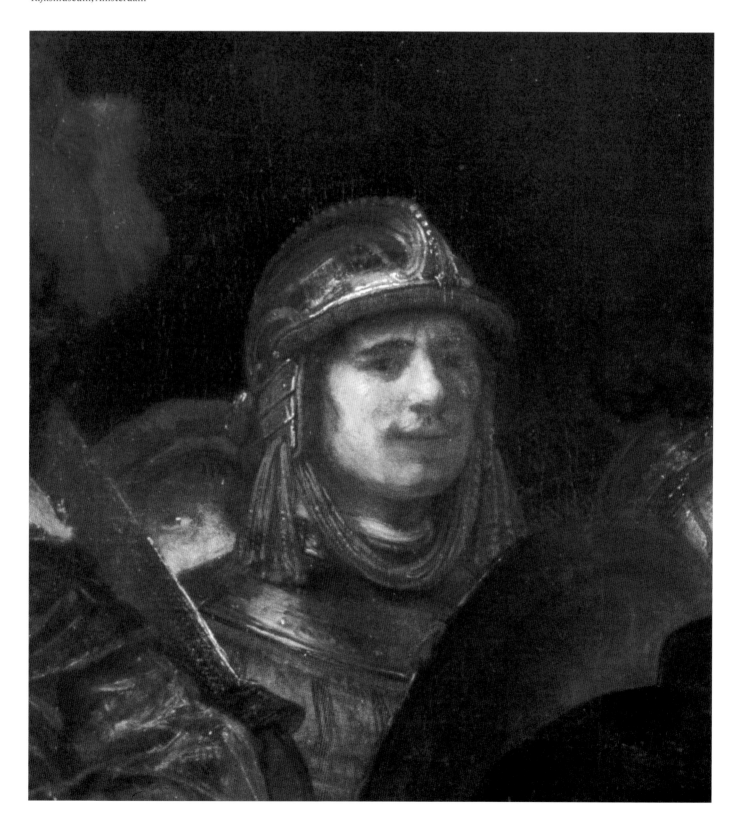

The Return of the Prodigal Son, 1636

Etching
Rembrandthuis, Amsterdam

And yet again – Rembrandt in the guise of servant gawping in astonishment as his master greets with love his returning wayward son.

History Piece, 1626

Oil on panel
Instituut Collectie Nederland
(in loan of Lakenhal, Leiden)

One of the earliest of Rembrandt's paintings – and there he is, at the back, in the crowd, dressed in livery and attending the hero of the piece.

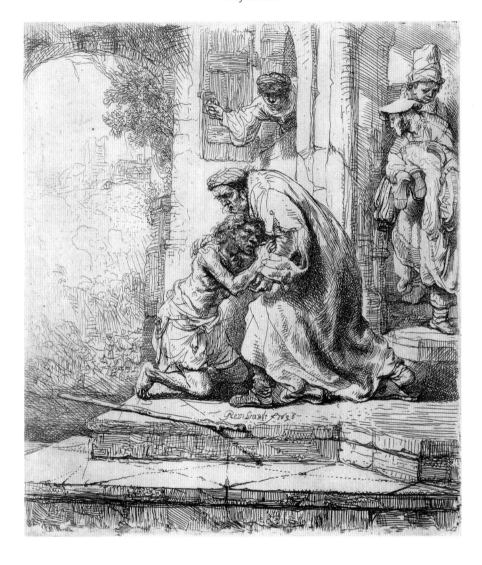

because it was large and heavy, he hired a barge man to carry it home for him. Titus was only 16 years old and slight of build. The bargee set off, calling out as he went: 'Friends, be careful, do not anybody bump into me for I am carrying an expensive piece here.' Half way across Ruslands Bridge there was the sound of a loud crack. *Een groote knack* they called it.

The broad span of the mirror had proved too much for one head to bear and the silvered glass had shattered and fallen to the ground in a shower of glittering shards.

All that remained for Titus to do was to take home to his father an empty ebony frame and the sorry tale of *een groote knack.*

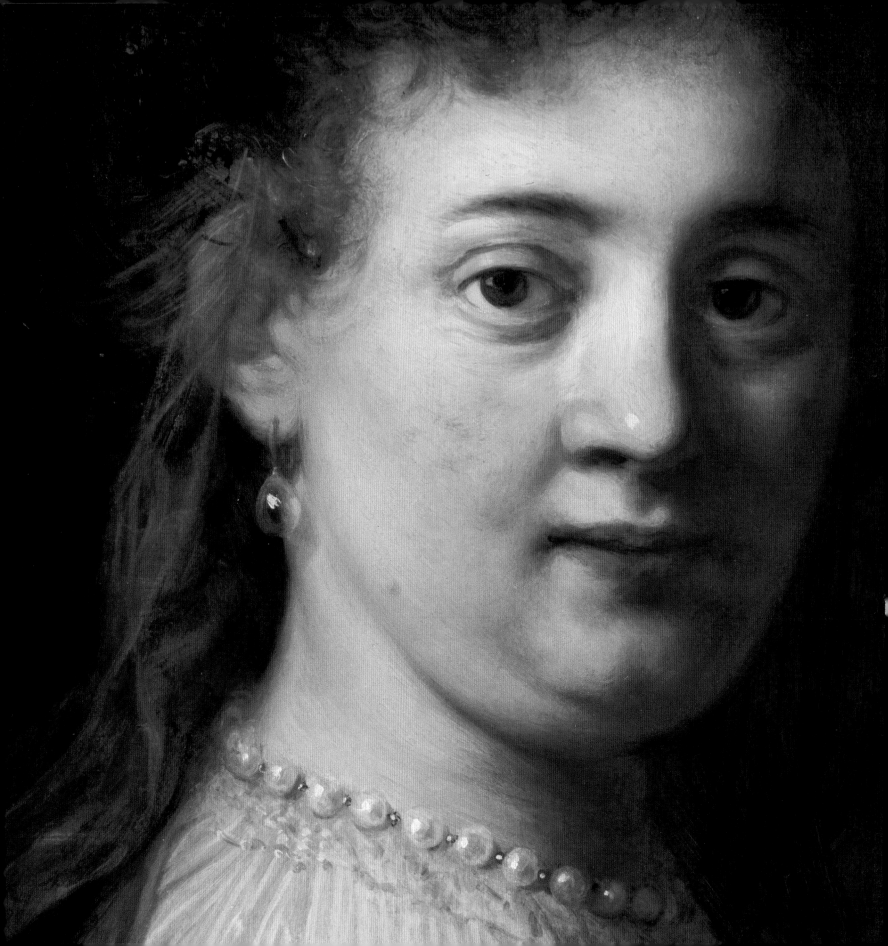

E
Engagement

No sooner had Rembrandt arrived to live in Amsterdam than he met the pretty young woman from Friesland who was to become his wife. They were virtually thrown together both by business and by circumstance. Her name was Saskia and she was an orphan. A wealthy one. After both her parents had died she would come to stay, on occasion, with her cousin the international art dealer, Hendrick Uylenburgh, in the very house in which Rembrandt now lived.

The impressive young artist had already invested money – a total of about 1000 guilders – in Uylenburgh's studio on the Breestraat and was closely involved in the day to day running of *la famosa accademia*.

Saskia Uylenburgh was sweet and shy and cultured and, although she was both well connected and in possession of a generous dowry, there seems no doubt that this was a love match. They became engaged on June 5, 1633, and to mark the happy day Rembrandt made a lyrical picture of his bride-to-be wearing a flowered hat and a soppy smile.

Despite the fact that Rembrandt was a grown man of 28, a successful artist in his own right and the owner of a part share in a business, for legal reasons a parent's consent still had to be given – and proven to be given. His father had died four years earlier and so his mother duly signified her agreement by making a cross on the official document. (Ironically, the woman who was, in all probability, the model for the memorable painting of the *Prophetess Hannah reading a book* was, in life, illiterate.)

A year after the engagement they were married – not that his mother, nor any member of his family was there. It was very much an Uylenburgh affair. From that time on, just about everything was very much an Uylenburgh affair.

The life of Saskia van Rijn was both short and sad. She bore Rembrandt four children. Only one of them lived to become a man and even he died in his twenties. Rembrandt survived them almost all, wife, mistresses and children.

The first, Rombertus, born in 1635, died when he was just two months old. The second, Cornelia, named after Rembrandt's mother (Neeltge is a diminutive of the name), was baptised in July 1638 and buried three weeks later. The third, again called Cornelia, lived only two weeks.

During this time, Saskia developed tuberculosis. It is not

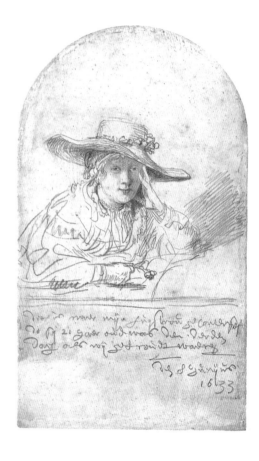

Saskia in a Straw Hat, 1633

Drawing in silverpoint
Kupferstichkabinett, Berlin

In love. Saskia wearing a straw hat and a soppy smile. Under her picture the artist has written: *This is a portrait of my fiancée at the age of twenty-one, three days after our engagement – 8th June 1633*

known how long she suffered, but the many touching sketches of his wife on her sick bed, her face lined with pain, chart her inexorable decline. Her companion on many of these days was Titia, the closest of her three sisters and four brothers, who came to stay in the grand house on Breestraat where they then lived. But this was a time of plague and in 1641, just a month or two before the birth of Saskia's fourth child, named Titus for his aunt, Titia fell victim to the disease.

Finally, on June 14, 1642, Saskia died, eight years almost to the day after the grand wedding in Friesland. She was not

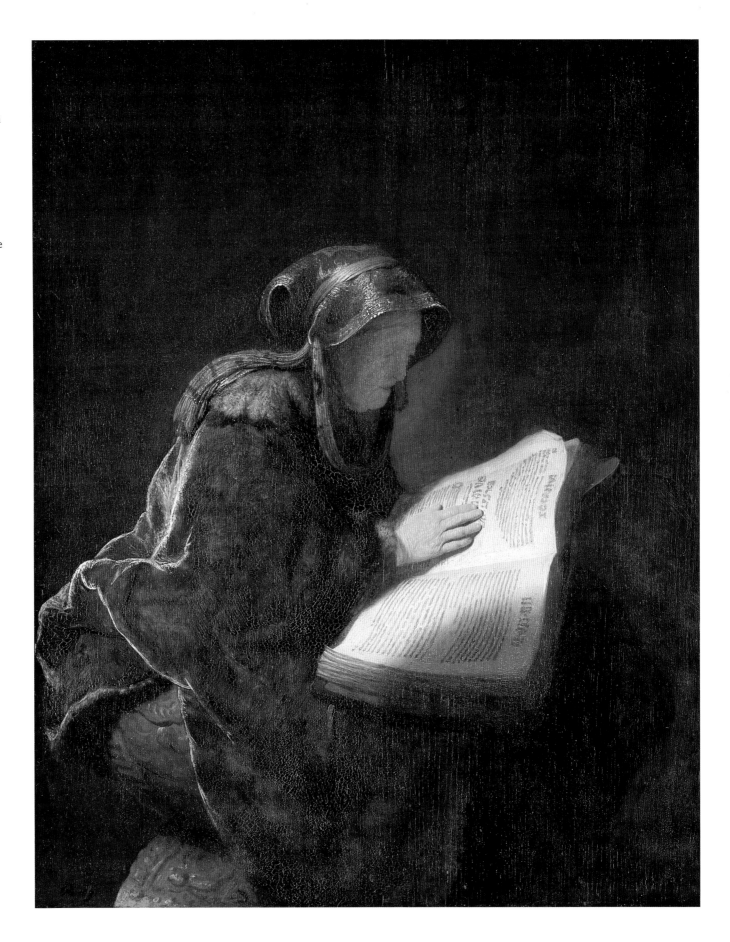

The Prophetess Hannah,
1631

Oil on panel
Rijksmuseum, Amsterdam

It may seem strange in today's highly educated world, but Rembrandt's mother who, it is said, posed for this picture of the learned Hannah, was in life illiterate. When she gave her consent to her son's marriage, she signed her name with a cross.

Oil on panel
Rijksmuseum, Amsterdam

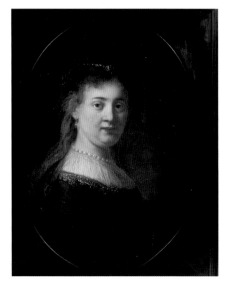

Oil on canvas
Hermitage, St. Petersburg

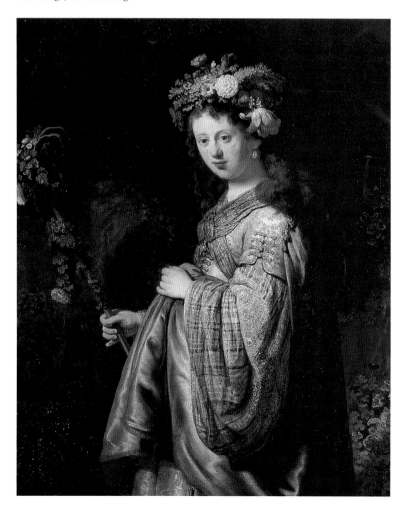

yet thirty. Titus, the only one of her children to survive her, was nine months old. Five days later Saskia was buried, not in the Zuiderkerk with her three children, nor in Friesland with the Uylenburgh family, but in a burial place her grieving husband had bought 'quite close to the organ and behind the pulpit' in the Oude Kerk. There was no epitaph for Saskia, save the portraits her husband had made of her in the days of wine and roses.

The sadness of the many deaths apart, the couple had lived well in the years of prosperity. They enjoyed a fine standard of living on her dowry and his pictures and gave all the signs of happiness. Now, everything changed. This was the beginning of vexatious times for the newly widowed Rembrandt – a period of legal wranglings, domestic strife and financial difficulties.

Just how difficult were the years to come can only be imagined from the fact that in October 1662, when plague once again raged through Amsterdam, Rembrandt sold the last resting place of his much loved wife to a grave digger who traded in such things.

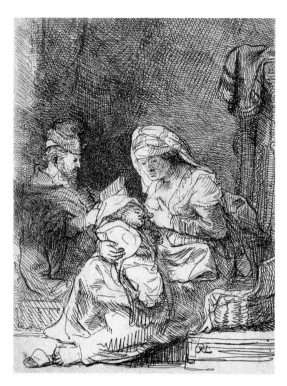

The Holy Family, c. 1632
———

Etching
Rembrandthuis, Amsterdam

An early etching, thoughtful and tender and signed RHL – Rembrandt Harmenszoon of Leiden.

Five studies of the head of Saskia, and one of an older woman, 1636 (detail)
———

Etching
Rembrandthuis, Amsterdam

Saskia, still young and healthy, before illness and bereavement had taken its toll.

Sheet of studies with a woman lying ill in bed, a beggar couple and several old men, c. 1641/2
———

Etching
Rembrandthuis, Amsterdam

Studies of several heads, including Saskia, in bed.

Page from a document in Leiden Municipal Archives
———

Rembrandt's mother, Neeltge van Suydtbroeck, signifies her consent to her son's wedding with a cross, 1634

→

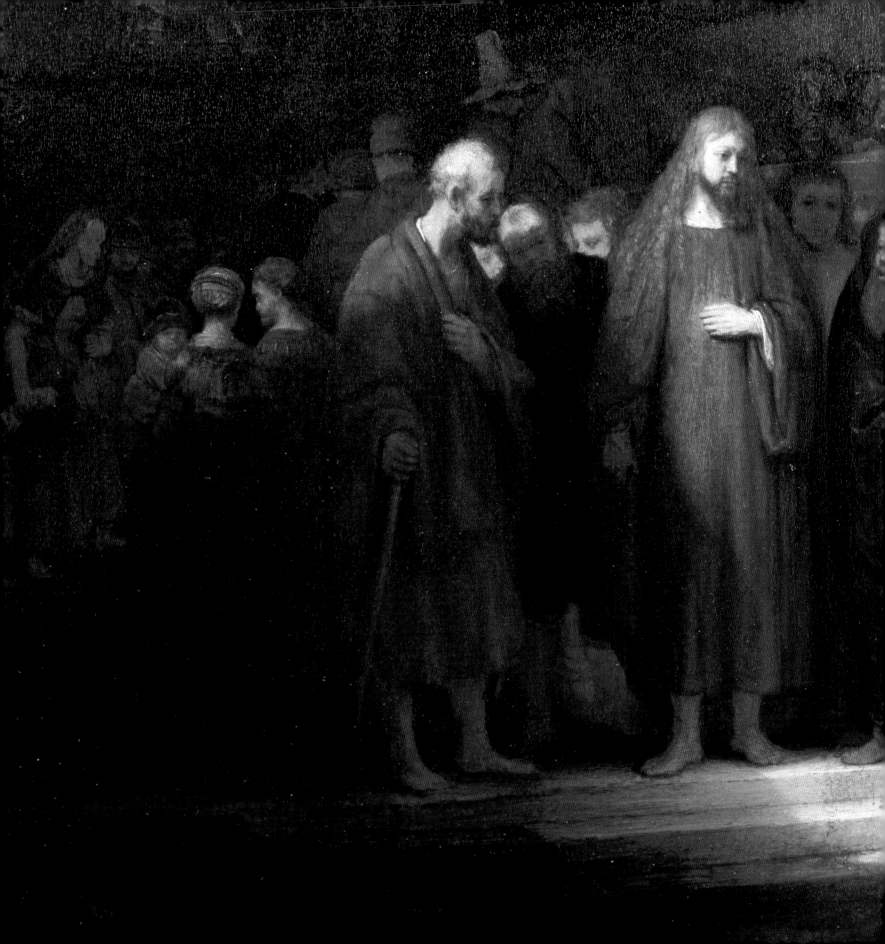

Finance

Ten days before she died, Saskia changed her will. Or, to be more exact, she made a new one. In it she left everything to her nine month old son, Titus. 'Saskia Uylenburgh, wife of the Honourable Rembrandt van Rijn (...) although sick in bed, yet in full control of her memory and understanding (...).' In the joint will they had made back in 1635, before the birth of Titus, they had left everything to each other. But, having Titus as sole heir was not the blow it might have been. The boy was under age and, as his son's only guardian, Rembrandt was allowed to use the money as he saw fit – or rather, as the ever watchful Uylenburgh relatives saw fit.

Although Saskia's father had died a wealthy man, he had eight children among whom to divide his estate. And because of the way his will was worded, not only the direct descendants but the in-laws and the in-laws of in-laws felt free to keep an interfering eye on the way they all spent their money. What made them so vigilant was that, in certain circumstances, inherited cash could be taken from one and given to another. The result was that, in 1638, one set of grasping relations claimed that Saskia – and Rembrandt by implication – had squandered her inheritance 'through flaunting and ostentation.' Rembrandt had sued them for libel, claiming that 'he, the plaintiff and his wife were blessed richly (...) a superabundance of wealth'. He not only lost the case, but the very fact of bringing the suit served only to feed his growing reputation for extravagance.

But, at the heart of Rembrandt's future problems was the purchase in 1639 of the fine house on the Breestraat, double fronted and grander by half than the rest of the grand houses on the avenue. The price was 13,000 guilders, more than Rembrandt could put his hands on. So, the owners agreed a kind of mortgage to be paid over the next five or six years, 'or as shall seem convenient.' The interest was five per cent. It seemed like a good deal at the time; he had plenty of commissions, plenty of students, plenty of prospects. The only trouble was – it never did *seem convenient*.

Just as the first instalment on the house was coming due, Rembrandt finished two more paintings for Frederick Hendrick. For the first two, made in 1633, he had been paid 1,200 guilders. Now, six years on in reputation and in skill, he

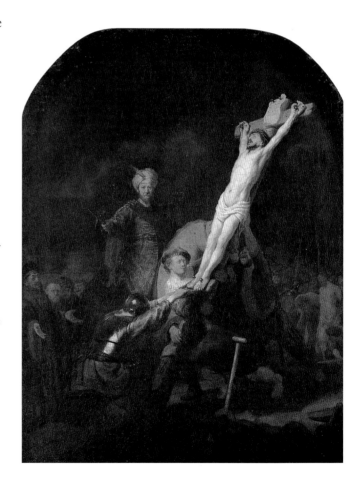

***The Elevation of the Cross,* c. 1633**

Oil on canvas
Alte Pinakothek, Munich

One of the paintings from the Passion of Christ series that Rembrandt made for the Prince of Orange, but for which he was only paid 600 guilders, rather than the 1000 he had hoped for.

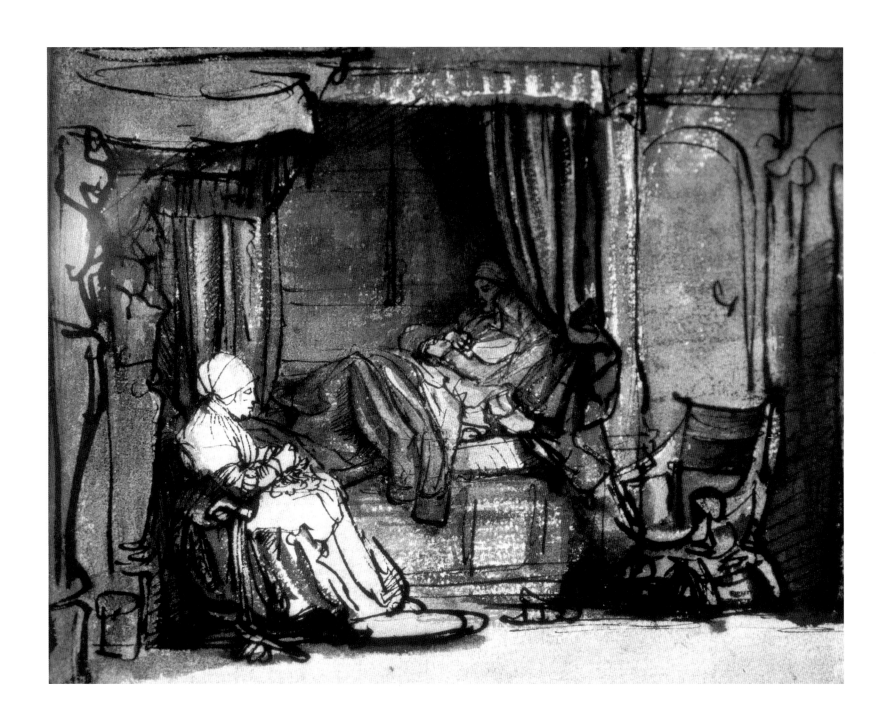

Living room with Saskia in bed,
c. 1641/2

Drawing in pen and brush
Fondation Custodia, Paris

Ten days before she died, Saskia made a
new will in which she left everything to
her infant son Titus.

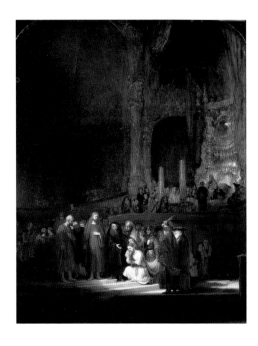

During the worst of Rembrandt's money problems, in 1654, his works were being handled by an independent dealer who might be trusted to get him the best possible prices. This painting, made some ten years earlier, was assessed by the dealer, Johannes de Renialme, for the princely sum of 1,600 guilders, almost three times what the artist earned per picture from Frederick Hendrick.

hoped his new paintings '(...) will be considered of such quality that His Highness will now even pay me not less than a thousand guilders each. But should His Highness consider they are not worth this, he shall pay me less according to his own pleasure.'

It was not exactly a pushy letter. It met with silence. A few weeks later, he wrote again to the Prince's Secretary, Constantijn Huygens: 'I would request you, my lord, (...) that I may receive this money here as soon as possible, which would at the moment be particularly convenient to me.' Still nothing happened. In February he wrote again: '(...) if His Highness cannot be persuaded in the face of valid arguments to pay a higher price, even if they are obviously worth it, I shall be content with 600 guilders each (...) I trust that with your kind help (...) I shall soon be able to enjoy my pennies.'

There was to be one more letter asking, yet again and still politely, for payment before an order was dispatched for a mere 600 guilders per picture.

Sheet of studies with self-portrait, a beggar
couple, heads of old man and woman, c. 1632

Etching
Rembrandthuis, Amsterdam

Sheet of studies with self-portrait, a beggar
man, woman and child, 1651

Etching
Rembrandthuis, Amsterdam

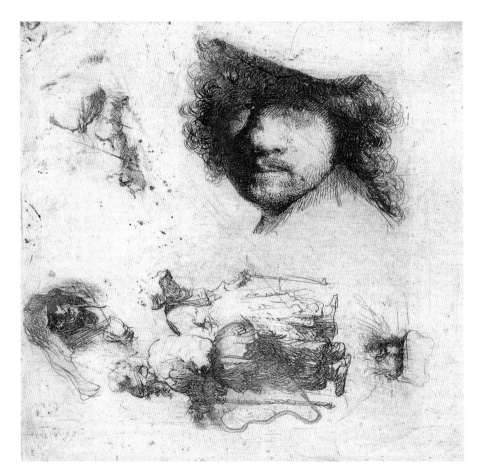

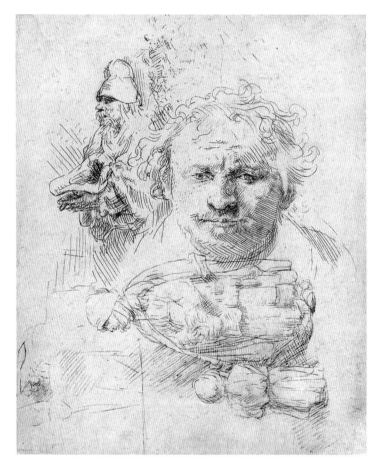

Fourteen years later, when the outstanding debt on the house amounted to nearly nine thousand guilders, the former owner decided he had to go to law to get his money. And so began a complex, complicated, convoluted round of borrowing that led ultimately, in 1657, to Rembrandt being declared insolvent.

The war with England, and the savage blockade of the Dutch ports by the English, were largely blamed for Rembrandt's money problems. His creditors, faced with losses at sea, had become desperate to reclaim loans willingly made in happier times.

Three years later, Rembrandt contrived to become the paid employee of his teenage son and his illiterate housekeeper, Hendrickje Stoffels. Under the master's guidance, they had formed themselves into a company to protect him from the men to whom he still owed money.

It might not have done much for his dignity, but it kept the creditors at bay. And it gave him free board and lodgings.

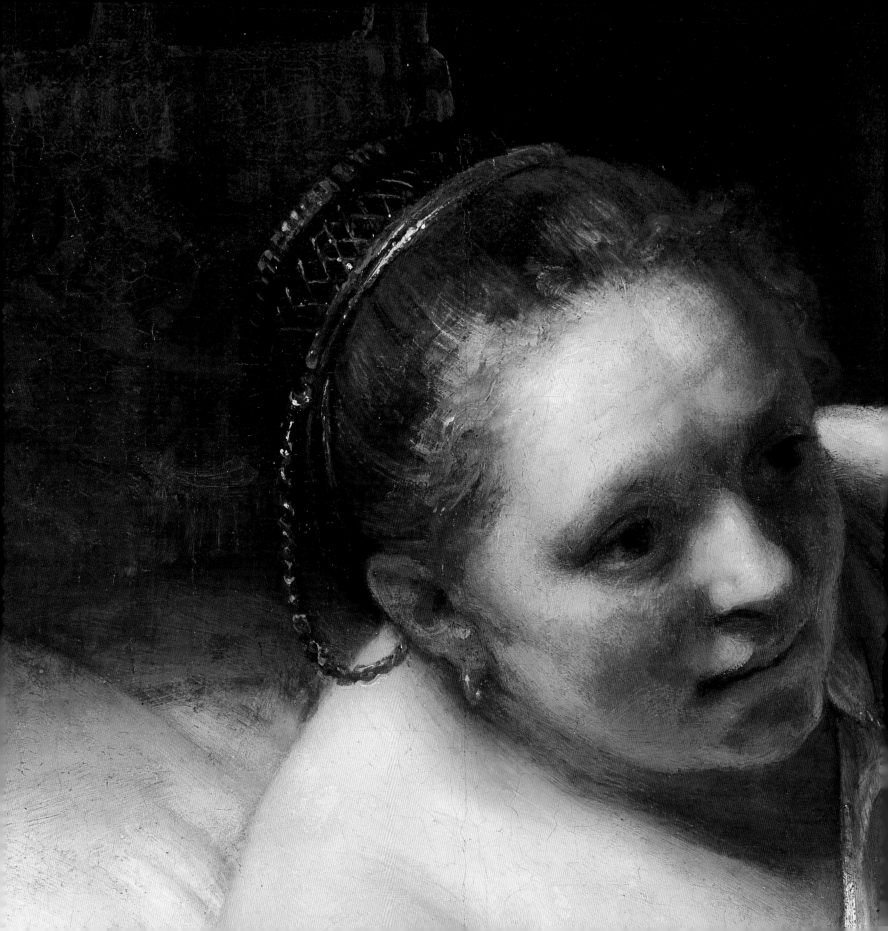

Geertje

Reclining Female Nude, 1646

Drawing in black chalk
Kunsthalle, Hamburg

There is no particular reason to think that this might be Geertje, except that at least one of Rembrandt's biographers has remarked that she is, indeed: 'rather small of person but well made in appearance and plump of body.'

Susanna and the Elders, 1647 (detail)

Oil on panel
Gemäldegalerie, Berlin
→

Susanna and the Elders, 1647

Oil on panel
Gemäldegalerie, Berlin

Susanna is the virtuous wife of a magistrate in a story in the Book of Daniel. A couple of deeply unpleasant elders of the church spy upon her while she is taking her bath and when she refuses their lecherous advances they threaten her with slander as an adulterous woman.
↓

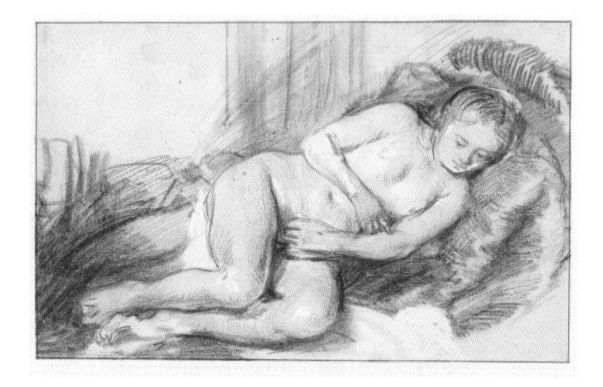

Seven years after Saskia's early death, Rembrandt was summoned to appear before the Chamber of Marital Affairs in Amsterdam. He was charged with breach of promise. A country woman named Geertje Dircx was claiming that Rembrandt had said he wanted to marry her. Now, despite having given her a ring, she said, he was refusing to keep his promise. She had been brought into the Breestraat house on Saskia's death to nurse the infant Titus who, at nine months old, was still being breast fed.

Geertje was a one-time waitress, the widow of a ship's bugler who had died not long after their wedding. She was 38 years old and although she never married Rembrandt there were several in their circle who assumed she was his spouse. One eighteenth century biographer referred to her as Rembrandt's wife, describing her as 'a peasant woman...small in figure but well-shaped of face and plump of body.' Most historians seem to regard the problems with Geertje as nothing more than a minor hiccup in Rembrandt's stormy life. One refers to it as a tragic love affair. The truth is probably somewhere in between.

The human story which emerges from the dry documents preserved over the centuries, begins eighteen months earlier, on January 24th, 1648, when Geertje, being seriously ill, makes a will. She leaves all her possessions, specifically her jewellery, to the boy Titus. Rembrandt, it seems, has not only been making her promises of marriage, he has been giving her the jewels he once gave to Saskia.

A year later Geertje, by now presumably recovered from her illness, realises that Rembrandt has no intention of taking her to the altar. In fact, there is now another helper in

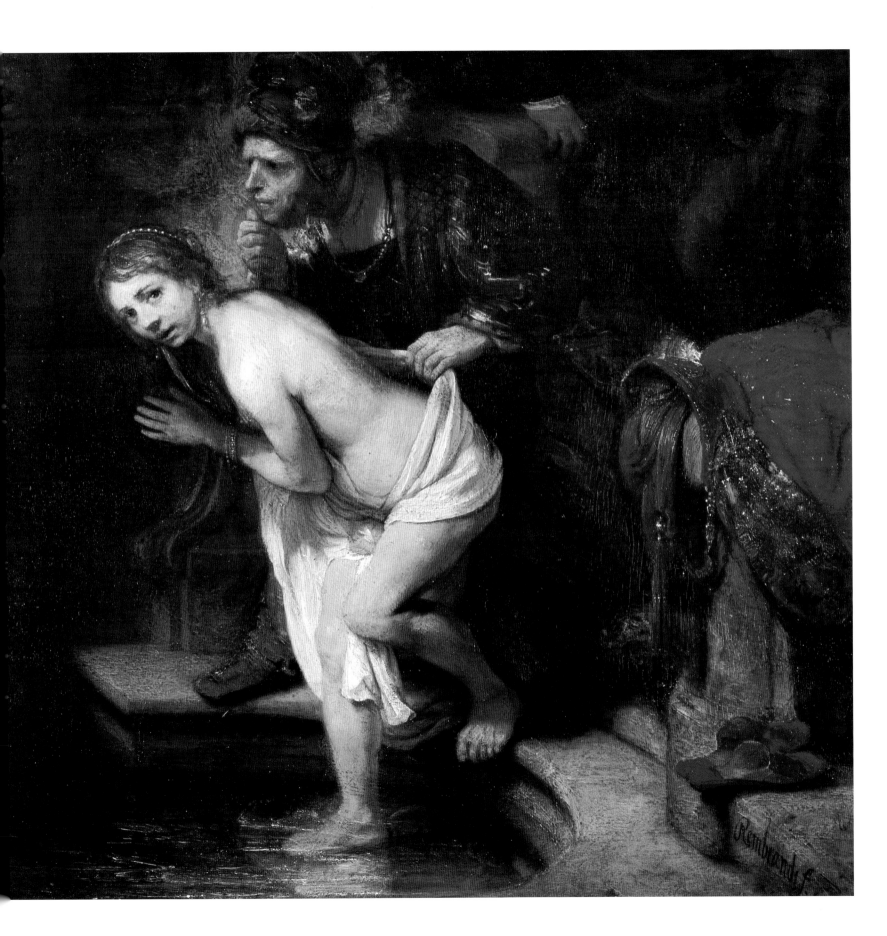

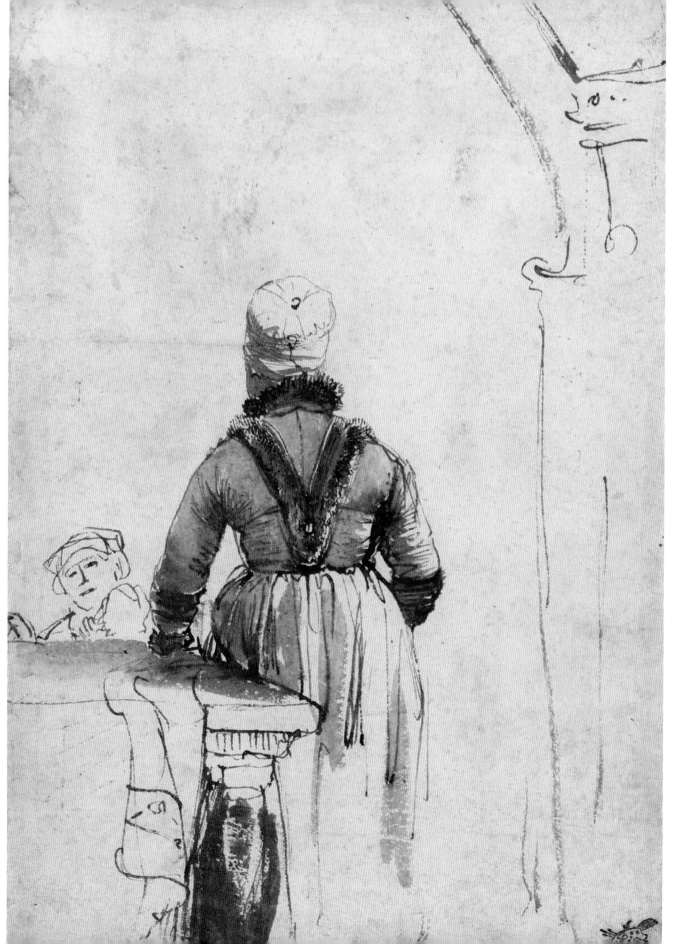

Woman in North Holland Dress, c. 1645

Drawing in pen and brush
Teyler Museum, Haarlem

There are two of these drawings of a woman in North Holland costume – where Geertje was from. On the back of one is written: *The wet nurse of Titus.*

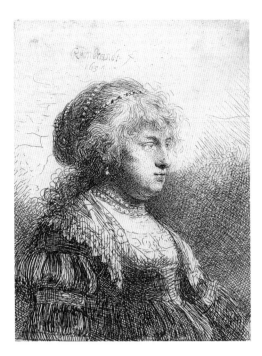

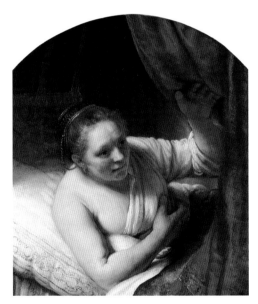

Saskia with Pearls in her Hair, 1634

Etching
Rembrandthuis, Amsterdam

Saskia wearing, in her hair, the pearls her husband gave her – and later gave to Geertje, who pawned them.

↑

Young Woman in Bed, c. 1647

Oil on canvas
National Gallery of Scotland, Edinburgh

It is popularly believed that the buxom young woman in this picture is Geertje. The date is certainly right.

↓

the house and, quite possibly, another love in Rembrandt's life. She is 23 years old and her name is Hendrickje Stoffels.

In desperation, Geertje asks for a separation agreement. If she can't have marriage, she wants money. Together they begin to try to work something out. And who should be in on those talks, as a witness? – none other than the new woman in Rembrandt's paintings, Hendrickje.

Rembrandt's offer did not please Geertje and it was at this point, on September 25, 1649, that he was summoned to appear before what was commonly known as the Crack-Throat Court. He refused to go in person. Instead he sent Hendrickje to tell the court that Geertje had accepted an offer of 160 guilders a year for life, plus a once-only payment of 150 guilders so that she could redeem some pieces of Saskia's jewellery that she had pawned.

Three times was Rembrandt summoned to court before he finally turned up to deny that he had ever had any intention of making the bugler's widow his wife. Geertje was defiant. Rembrandt, she told the court, had made 'verbal promises of marriage and had given her a ring; and that furthermore he had slept with her on numerous occasions.' The Commissioners decided that perhaps it was not proper to force such a man to marry 'a servant girl'. Instead he should pay her 200 guilders immediately and 200 a year for life. She might keep the jewellery so long as she did not pawn it or sell it and left it to Titus in her will.

From that time on everything went from bad to worse for Geertje. She began, once again, to pawn Saskia's pearls and rings. This so infuriated Rembrandt that, together with certain members of her family (who stood to collect her money in her absence), he applied to have her put in a house of correction. As a result, Geertje was committed to a place of 'whores and vagabonds' in Gouda for twelve years. The cost of the committal procedure was paid by Rembrandt.

It was to be six years before Geertje succeeded, with the help of a few loyal friends, in getting herself released. By this time her health was gravely damaged. This was 1656, the year in which Rembrandt's money problems came to a head. He had long since fallen behind on his payments to her. Seven months after her release, at the age of forty-six, she died. She did not live to see him forced to sell the grand house where once she had reigned as mistress.

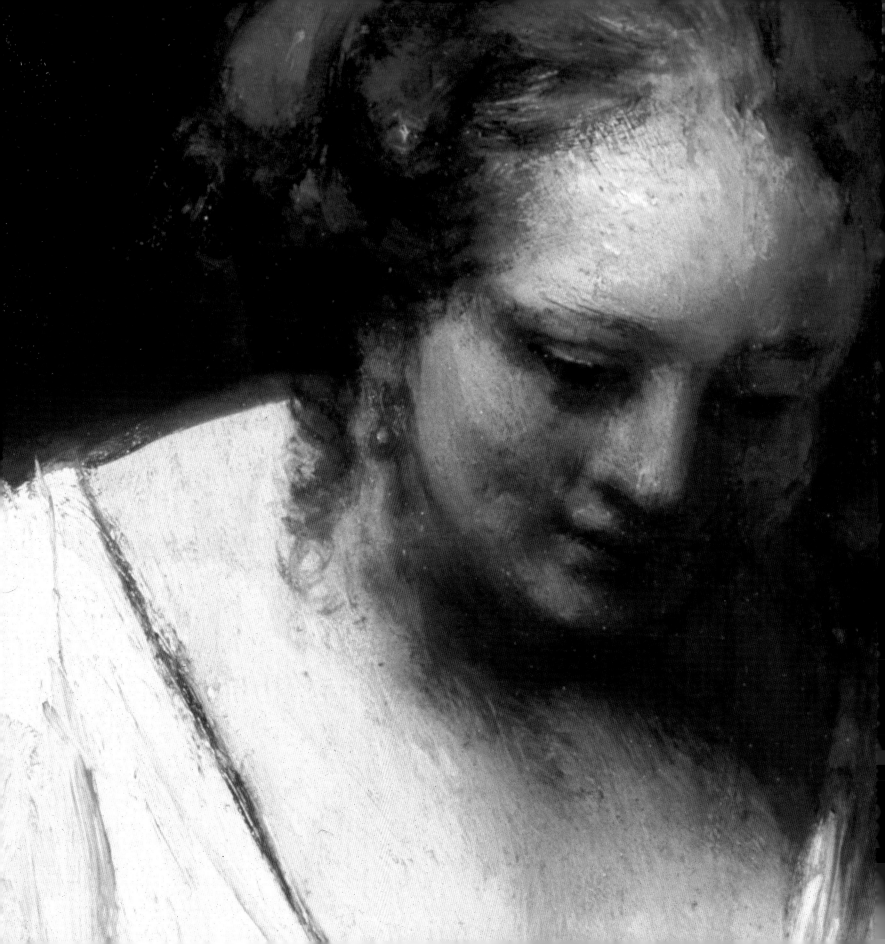

Hendrickie

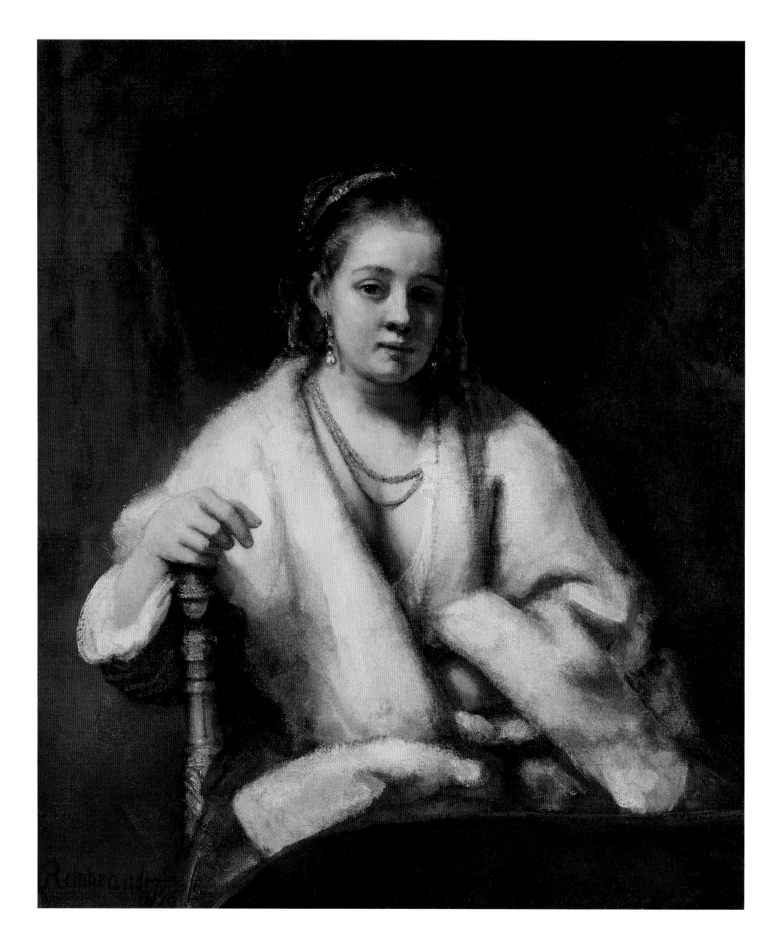

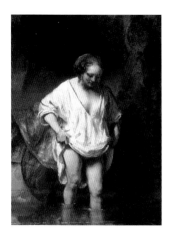

Woman Bathing in a Stream, 1654

Oil on panel
National Gallery, London

It is not too great a leap of the imagination, given the date and the voluptuous form of the model, to think that this woman in a stream is Hendrickje.
↑

Woman in the Artist's Studio, c. 1654

Drawing in pen and brush
Ashmolean Museum, Oxford

Same date. Could it be the same woman?
→

Portrait of Hendrickje Stoffels, c. 1654/6

Oil on canvas
National Gallery, London

The woman who came as nanny to the son and stayed to become a common-law wife to the father.
←

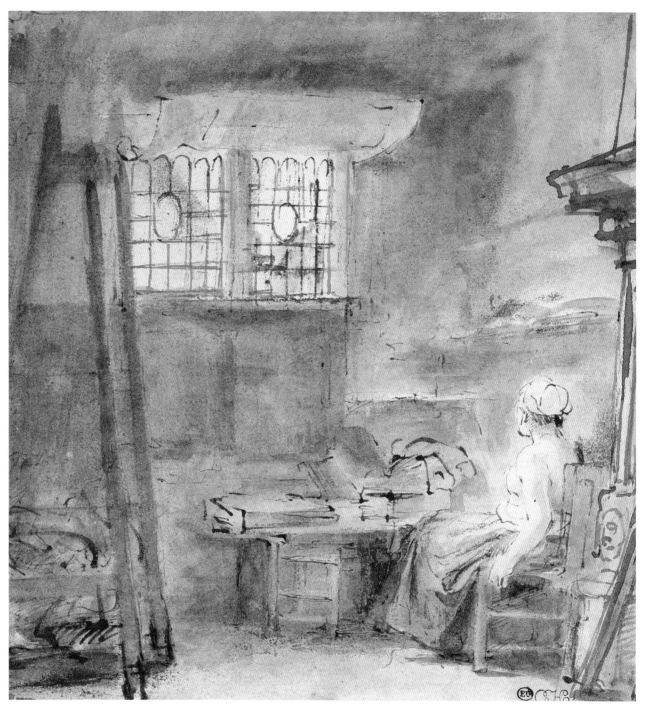

49

Five years after the inelegant departure of Geertje Dircx, it was the turn of her successor, Hendrickje Stoffels, to be called to account for her behaviour. She was charged with 'living in whoredom with the painter Rembrandt van Rijn'. Titus's comely young nanny was heavily pregnant and it was no longer possible to hide the true nature of her relationship with her master. Gossip about her condition had reached the elders of the Dutch Reformed Church to which she belonged. In June, 1654, she was summoned to appear before them to face accusations of living in sin or, translated literally in the brutal language of the seventeenth century: *living in whoredom.*

Hendrickje Stoffels was a child of the military, brought up at Bredevoort where her father, an Army sergeant, was garrisoned. Two of her brothers were soldiers and one of her sisters was married to another. Such a respectable, if humble,

family cannot have taken kindly to Hendrickje being called a whore. She was 28 years old, with sloe dark eyes and fair skin, and although she had a look of almost child-like innocence, she was endowed with a figure of such earthiness that she was to become the model for some of her master's most sensual paintings.

She had been in Rembrandt's household for nearly six years when the first summons arrived. She ignored it. So did Rembrandt. The second, addressed to her alone, was also ignored; and the third; at which point the 'brothers of the quarter' decided that she should be visited at home and 'exhorted'. Rembrandt had only been called the once. Finally, on the fourth summons, Hendrickje presented herself, six months pregnant, and there admitted that she had lived in sin with Rembrandt. She was 'admonished severely, urged to repent and forbidden to attend the Lord's Supper.' It is not known whether she was ever allowed back into the church as,

seemingly unabashed, she continued to live with Rembrandt, through good times and through bad, until the day she died.

In the autumn of 1654, three months after her humiliation, a healthy, thriving daughter was born to Hendrickje and Rembrandt. The baby was called Cornelia after Rembrandt's mother, the third of his children to be so named but the only one to live more than a few months. She was, in fact, the only one of his five children to outlive him.

Rembrandt never did marry Hendrickje. Unlike Geertje, it seems she understood and accepted his reasons, which probably had less to do with her humble status than with the terms of Saskia's will. Had he married again he would have lost the freedom to use the money bequeathed to Titus.

Nonetheless it would seem that Hendrickje was accepted as Rembrandt's wife by the people among whom they lived. There is a curious document preserved in the Municipal Archives in Amsterdam which records the fact that Hendrickje and two of her neighbours were witnesses to an incident involving a drunk on their street in October, 1661. In it she is listed as 'huysvrouw van Sr. Rembrant van Reyn, fijnschilder' – wife of Mr. Rembrant van Reyn, fine painter. The document records that Hendrickje saw a drunken surgeon showing 'great insolence and wantonness.' Rembrandt's son, Titus, signed his name as a witness; Hendrickje made a cross.

When bubonic plague once again ravaged Amsterdam in 1663, Hendrickje was one of the nine thousand in the city to die. In that year one in seven people in Holland died of the black death. She was buried in a rented grave in the Westerkerk on July 24. She was 37 years old and had never married.

Her daughter, Cornelia, lived with Rembrandt into his old age and was with him when he died. She was just fifteen. A year later she married a painter, moved to Batavia (modern Jakarta in Indonesia) and had two children whom she named Rembrandt and Hendrickje.

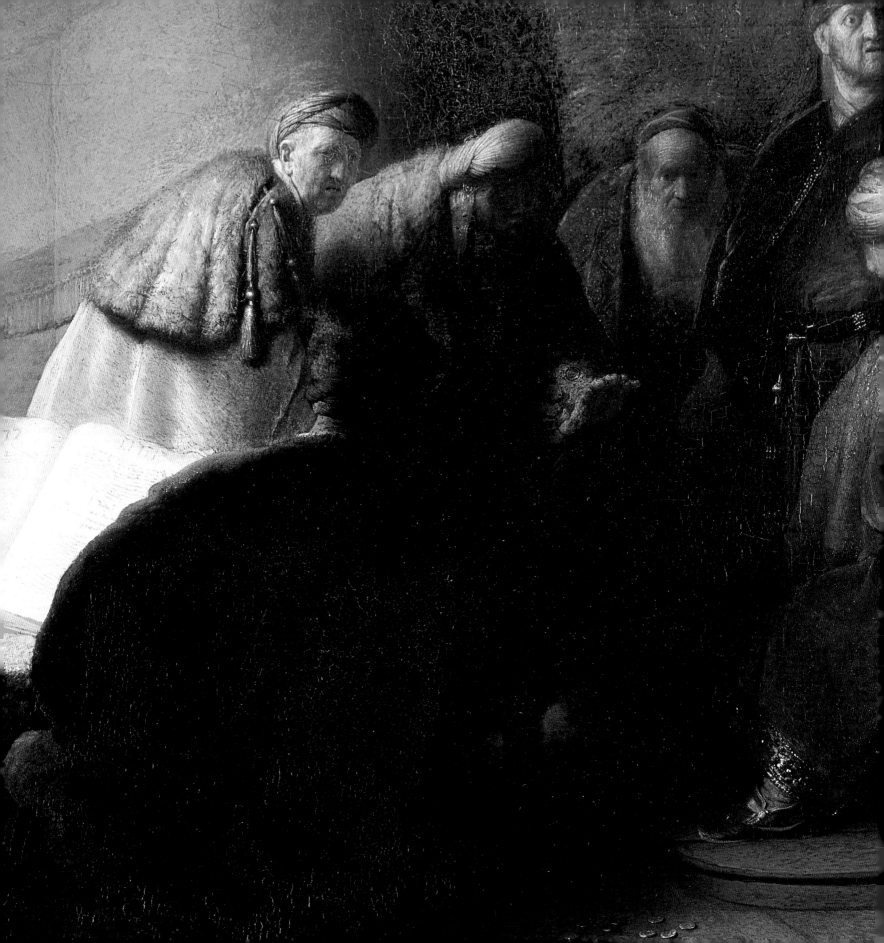

Italy

Repentant Judas Returning the Thirty Pieces of Silver, 1629

Oil on panel
Private collection

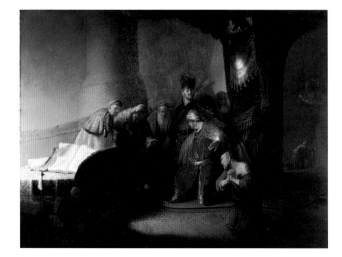

The Last Supper (after Leonardo da Vinci), c. 1635

Drawing in red chalk
Metropolitan Museum of Art (Robert Lehman Collection), New York

Rembrandt made three drawings of *The Last Supper* and there was a print of Leonardo's work in his collection.

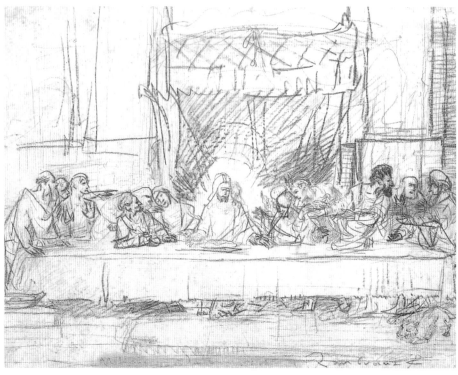

It was brave man, or a foolhardy one, who denied a patron in the seventeenth century. But, all his life, young and old, Rembrandt was his own man. There was never a time when he was going to be told what to do or how to do it, not by anyone, no matter how grand or influential. Which may go some way toward explaining his ultimate rift with one of the most important men in the Dutch art world, Constantijn Huygens, secretary to the Prince of Orange. And others, if it comes to that.

In 1628, when Huygens made his personal discovery of the two young artists, Rembrandt and Lievens, he thought they were 'miracles of talent'. There was only one point of dissent. In an early autobiography, published in 1631, Huygens tempered his vigorous praise with vigorous criticism. He called them 'lazy, idiotic, opinionated know-it-alls'. And for good measure: 'carelessly content with themselves.'

What had made Huygens so irritable was their point-blank refusal to make the artistic pilgrimage to Italy – a journey that Huygens himself had undertaken with due respect and reverence long before he was their age. He believed it could do them nothing but good. 'Oh, how I would like them to become acquainted with Raphael and Michelangelo (...). How quickly would they then be able actually to surpass all, so that from then on it will be the Italians [who would] come to Holland [rather than the other way around] – these two who, whether they know it or not, were born to raise the art of consummate perfection. Nor will I pass in silence over the pretext with which they always seek to excuse what is nothing but sheer laziness'.

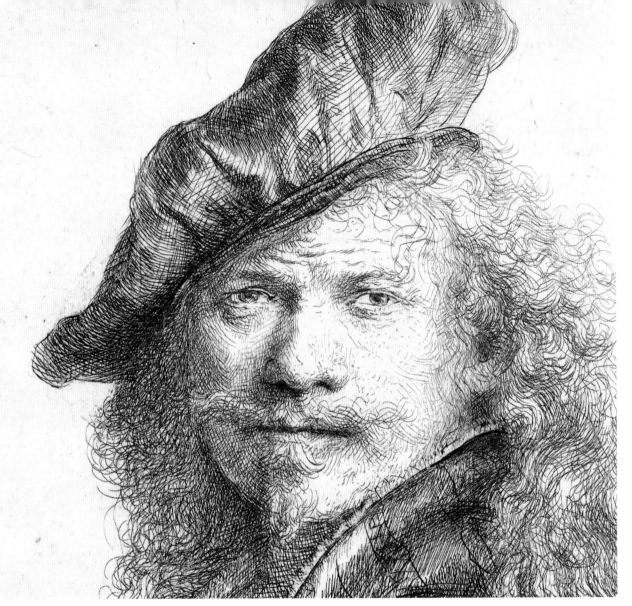

Self-portrait Leaning on a Stone Sill,
1639 (detail)

Etching and drypoint
Rembrandthuis, Amsterdam

A self-portrait done in the style of the very
men whose work Huygens was so anxious
that Rembrandt should go to Italy to see.
←

Self-portrait Leaning on a Stone Sill, **1639**

Etching and drypoint
Rembrandthuis, Amsterdam
↓

Their pretext, as Huygens put it, was that they had no wish to squander good painting time in travel. The journey to Italy would take months, lurching across Europe in draughty stage coaches, braving alpine weather and risking highway robbery. And for what? Rembrandt was already well 'acquainted with', and deeply influenced by, Italian art. His teacher Pieter Lastman had studied in Italy in his youth, even it was rumoured with Caravaggio himself. During those six months with Lastman, Rembrandt had absorbed much of his master's knowledge of the Renaissance painters and never failed to seek out examples of their work. He made a point of going to auctions where work by the Italians might be for sale.

He was there, at the sale in Amsterdam when Raphael's *Portrait of Baldassare Castiglione* came under the hammer, but even Rembrandt, a reputedly generous bidder, could not compete with the successful buyer – an agent for the King of France. The price they paid was 3,500 guilders. Rembrandt had to make do with a quick sketch of the Raphael, which he

later used to make a portrait of himself in the Castiglione pose. In 1656, when Rembrandt's possessions came under the scrutiny of clerks from Amsterdam's Bankruptcy Office, their inventory revealed a great collection of prints by (or after) the Italian masters – a source of constant inspiration.

Huygens' irritation, however, was virtually forgiven and forgotten when he came upon Rembrandt's painting of a repentant Judas Iscariot. He saw in it a work that could rival anything produced in Italy – and that, for Huygens, was praise indeed: 'It can withstand comparison with anything ever made in Italy, or for that matter with everything beautiful and admirable that has been preserved since the earliest antiquity. (...) That single gesture of the desperate Judas (...) I place against all the tasteful art of all time past, and recommend to the attention of all the ignoramuses who hold that our age is incapable of doing or saying anything better than what has already been said or... achieved (...) that which (and I say in dumb amazement) a youth, a born and bred Dutchman, a miller, a smooth-faced boy, has done.'

Neither of the two ever did go to Italy. Lievens went to London, where he painted for the King. Rembrandt went to Amsterdam.

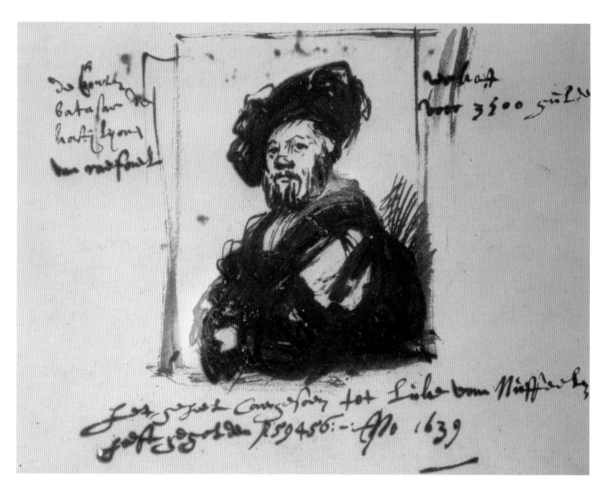

Portrait of Baldassare Castiglione (after Raphael), 1639

Drawing in pen
Graphische Sammlung Albertina, Vienna

Rembrandt made a point of going to auction sales where the work of the Italians was on offer. This is a sketch he made of Raphael's *Portrait of Baldassare Castiglione.* An agent for the King of France paid 3,500 guilders for the picture.

Self-portrait at the age of 34, 1640

Oil on canvas
National Gallery, London

A year after the auction, Rembrandt painted a self-portrait inspired by the Raphael.
→

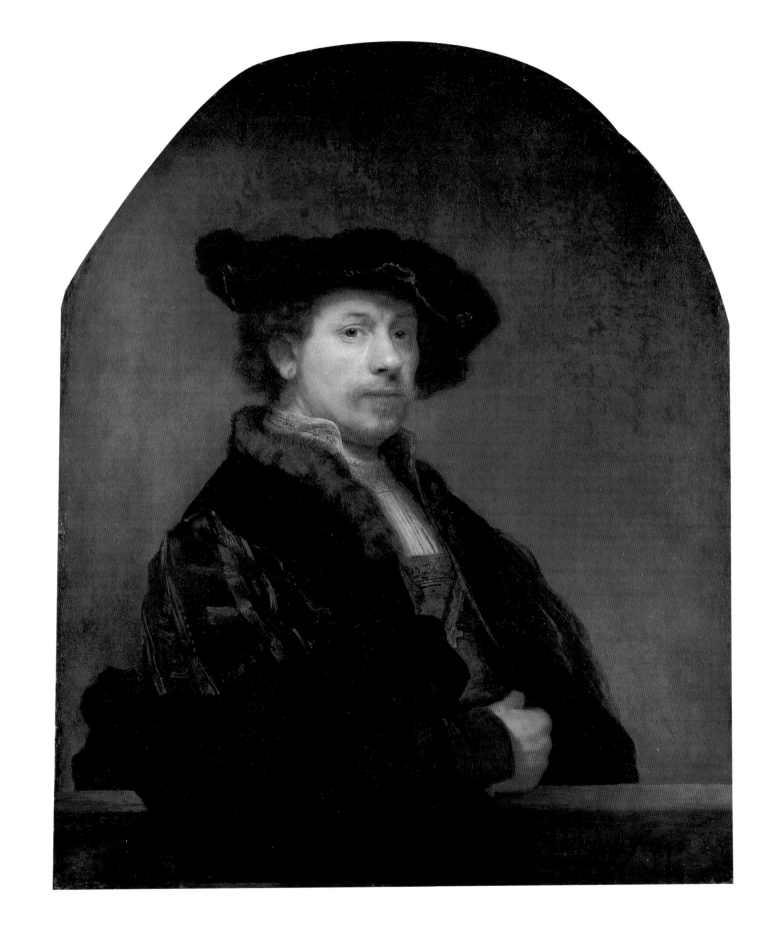

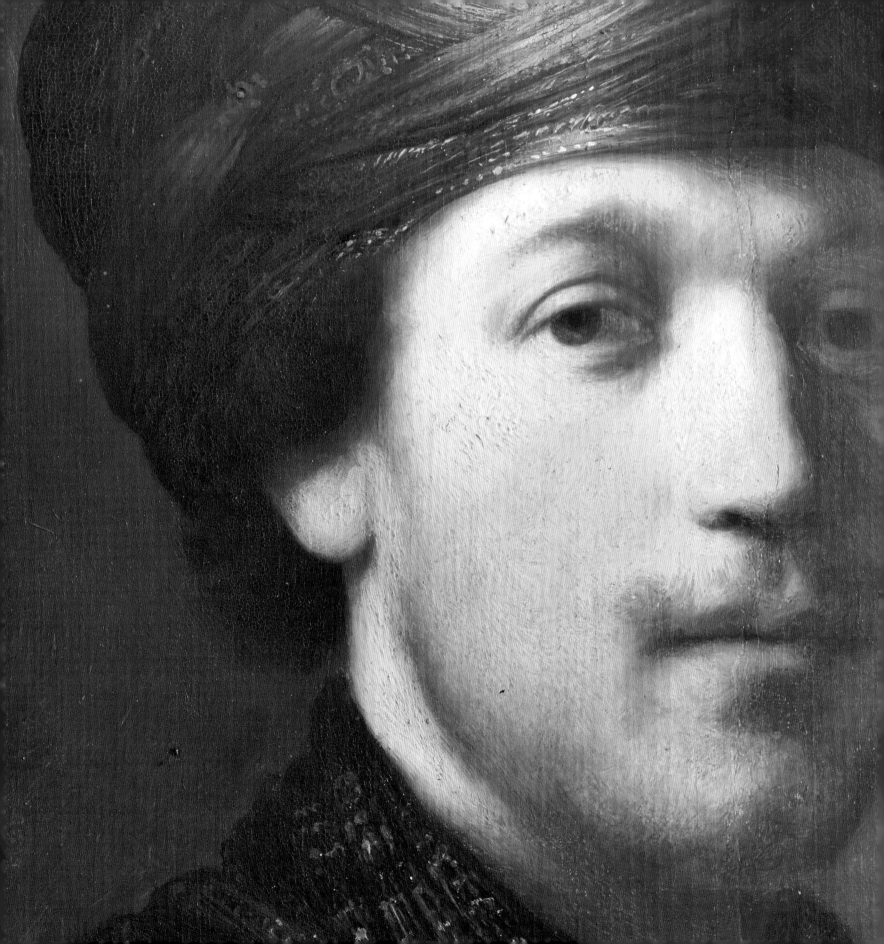

J

Jouderville

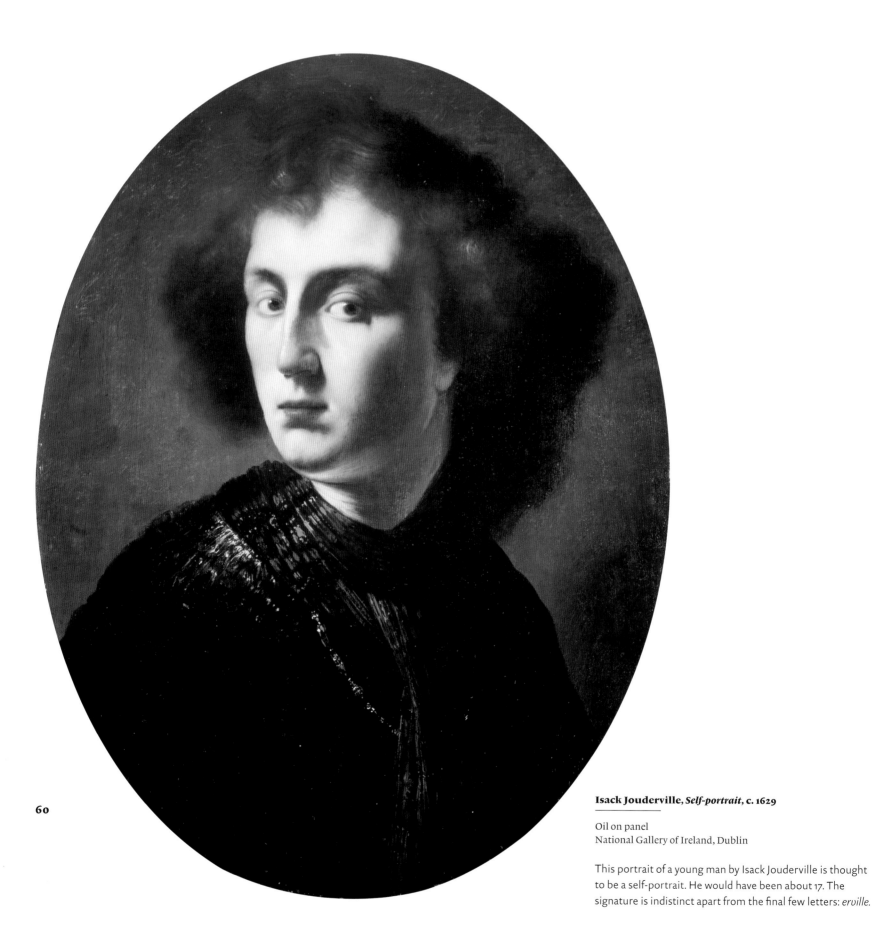

60

Isack Jouderville, *Self-portrait*, c. 1629

Oil on panel
National Gallery of Ireland, Dublin

This portrait of a young man by Isack Jouderville is thought to be a self-portrait. He would have been about 17. The signature is indistinct apart from the final few letters: *erville.*

Not many people have heard of the Dutch painter Isack Jouderville, yet his pictures hang in some of the grandest galleries in the world. Not that anyone knew they were his until recently. For centuries they were believed to be the work of his teacher, Rembrandt. Some of them still are – believed to be, that is.

One of the paintings in the collection of Queen Elizabeth II is the work of Isack Jouderville – or so it has been suggested. It hangs in Windsor Castle alongside works by great masters and is called *Young Man in a Turban*. Another is in the Walker Art Gallery in Liverpool, still proudly and resolutely titled *Self-portrait by Rembrandt*, despite the fact that certain experts have decided that it is no such thing. All such attributions and de-attributions are, of course, the subject of heated debate.

Some of Jouderville's paintings were all his own work. Some he finished for the master. Some were deliberate copies under the guidance of the master. Some were sort of half and half.

A British expert with strong views on the subject describes Jouderville as 'a great dustbin into which is cast anything that is not quite up to Rembrandt.'

Jouderville was Rembrandt's second pupil. More is known about him than any other of Rembrandt's pupils for the simple fact that he was an orphan and his guardians had to account, in detail, for the care of their charge. Everything was recorded and preserved – even the receipts from Rembrandt for Isack's fees – a total of 100 guilders a year. For such a fee a student would be equipped to '*honourably earn his living*', much as if he had been taught plumbing or thatching. And as soon as Isack had completed his apprenticeship with Rembrandt, his guardians sent him off with just enough money for paints, materials and a one way boat ticket to Amsterdam.

There is, in the National Gallery of Ireland in Dublin, a portrait of a young man believed to be of Jouderville by Jouderville. If it is, it would have been made when he was about 17. It shows a solemn, somewhat effeminate youth with protuberant eyes and a sensual mouth. It is signed, so far as anyone can decipher, with his name.

Most of the works now attributed to him are signed with another. This is by no means peculiar to Jouderville. In the seventeenth century this was the way it was. Paintings from the workshop of a famous artist were frequently marked with the signature of the master – the symbol of his studio. Pupils were encouraged to copy great works – that was how they learned their trade. And, once they had acquired the

Self-portrait with a Gold Chain, c. 1630 (detail)
———
Oil on panel
Walker Art Gallery, Liverpool

For hundreds of years this picture has been attributed to Rembrandt and is proudly labelled as such by the experts at Liverpool. Now that attribution is in doubt – the subject of hot debate. It has even been suggested that it is by Jouderville. Born in 1612 in Leiden, in 1630 he would have been 18.

Isack Jouderville, *Young Man in a Turban*, c. 1630
———
Oil on canvas
Royal Collection, Windsor Castle

Previously thought to be by Rembrandt, now attributed to Jouderville.

Lamentation over the Dead Christ, c. 1635/45 (detail)

Oil on paper and canvas glued to panel
National Gallery, London

Lamentation over the Dead Christ, c. 1635/45

Oil on paper and canvas glued to panel
National Gallery, London

A painting with a complex history. The central part was done by Rembrandt on pieces of paper. Other parts, especially the upper part, have been added later in his studio and were done by a pupil or an assistant.
→

necessary skills, they were also required to fill in the boring bits – the background, the clothes, sometimes the hands – of a portrait by their teacher.

According to contemporary reports, an 'almost countless' supply of students could be found in Rembrandt's workshop, together with visiting clients, passing art lovers, children, patrons, friends and even their dogs. A studio was not a place for quiet contemplation.

In his early days Rembrandt himself made pictures 'after' those of his teacher, Pieter Lastman. The only difference in his case was that, by taking the master's picture apart and putting it back together again, his way, the Rembrandt way, the picture he produced was rather better than that of his teacher. And his work was never, so far as is known, mistaken for Lastman's.

A biographer of Govert Flinck, who studied with Rembrandt for a year, wrote that in 'this brief time' Flinck's work was 'sold as the true brushwork of Rembrandt.' It is stated as a matter of pride.

And a seventeenth century historian in Leiden wrote, with what might be described as pride, that by the age of 12 Lievens was copying other painters so well that 'knowledgeable art lovers were unable to distinguish between the originals and the copies'. Lievens was never a pupil of Rembrandt's, but the two young artists are believed to have shared a studio in their home town and the chances of getting their work confused must have been enormous.

Throughout his career Rembrandt was considered to be very *avant garde,* which is why he always had a great many students. He was the new style. He didn't stick to the rules. He was, by all accounts, a good teacher but a hard taskmaster.

Samuel van Hoogstraten, who was apprenticed to Rembrandt at the age of 14 after the death of his father, later wrote: 'Sometimes depressed by my master's teaching, I would go without eating or drinking, and, shedding copious tears would not leave my work until conquering the fault in which my nose had been rubbed.'

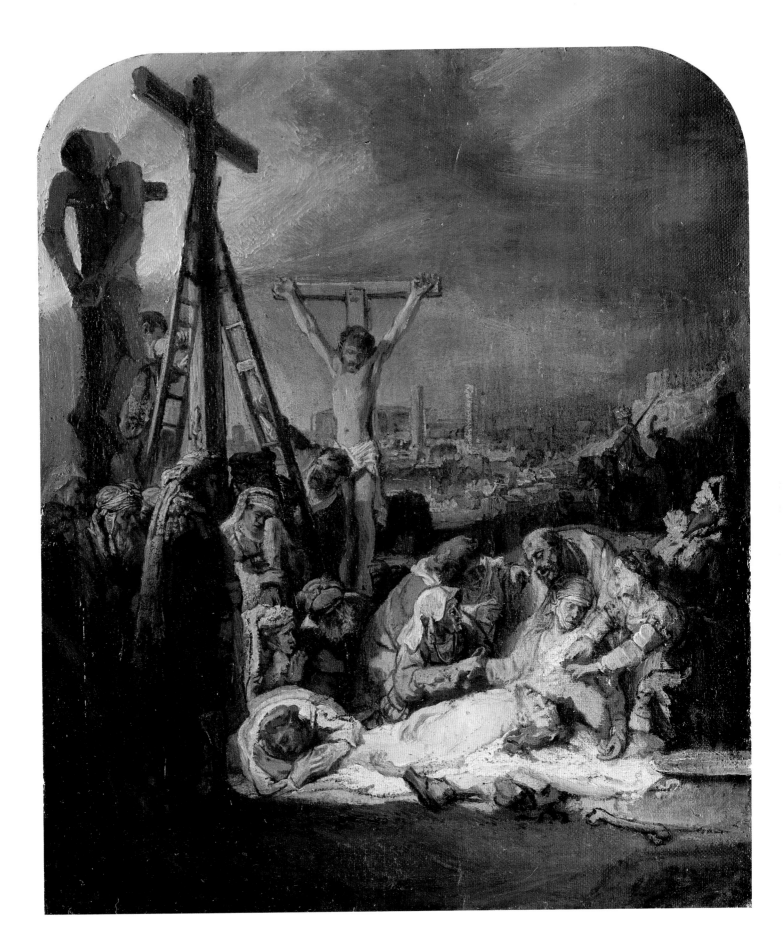

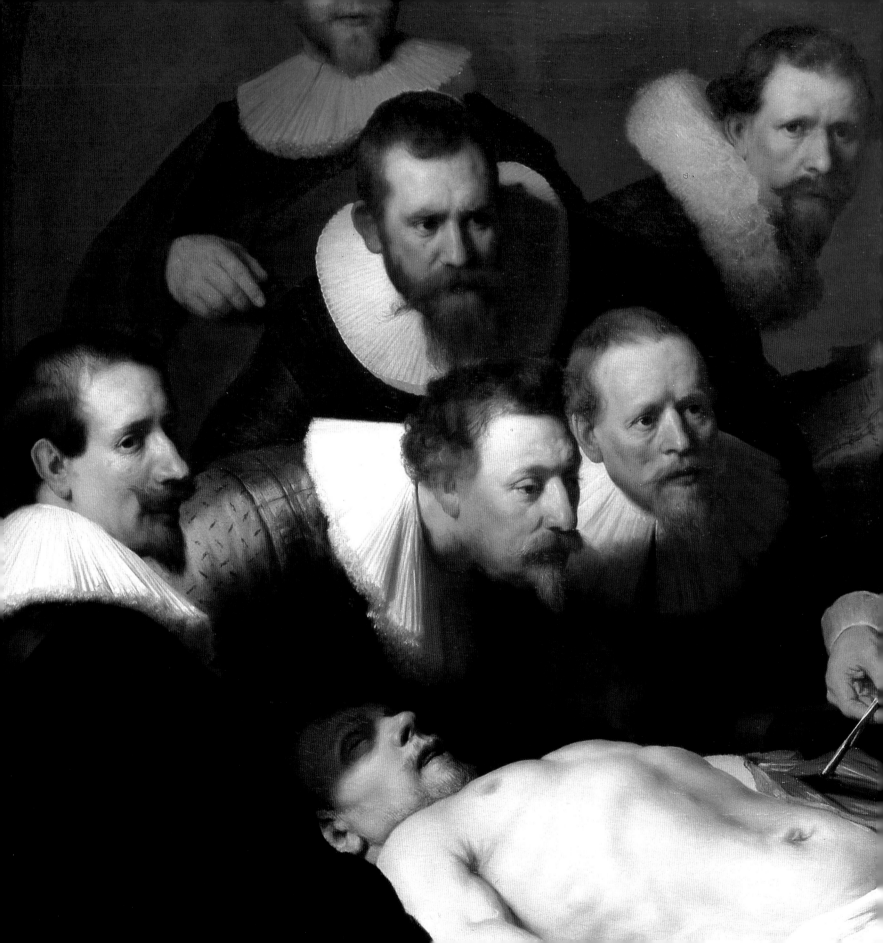

Kindt the Kid

The Anatomy Lesson of Dr. Tulp, 1632 (detail)

Oil on canvas
Royal Cabinet of Paintings Mauritshuis,
The Hague

To avoid shocking his public, the young
Rembrandt chose to show Dr. Tulp dissecting
the arm of Kindt the Kid, instead of emptying
out the intestines for general inspection, which
the good doctor would in truth have done.
→

The Anatomy Lesson of Dr. Tulp, 1632

Oil on canvas
Royal Cabinet of Paintings Mauritshuis,
The Hague

The painting that was virtually to be
Rembrandt's 'calling card' on his arrival in
Amsterdam.
↓

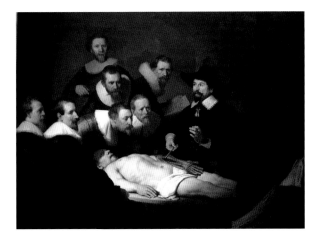

Aris Kindt was known as Kindt the Kid, just as William
Bonney, his rather more glamorous but equally lawless
namesake, was known as Billy the Kid in the Wild West of
America centuries later. But there was nothing glamorous
about Kindt the Kid. No one wrote books or made movies or
sang songs about him. They just put his mutilated corpse in
a picture. In fact, had it not been for Rembrandt, the young
artist from the thief's home town of Leiden, no-one would
have heard of Kindt.

Aris Kindt ended a violent life in violent death. On the
gallows. After which he was cut down and carted off to the
operating theatre of one Doctor Nicolaes Tulp, a famous
Dutch surgeon living in Amsterdam. *The Anatomy Lesson*
became something of a calling card for Rembrandt on his

The Anatomy Lesson of Dr. Deyman, 1656

Drawing in pen
Amsterdams Historisch Museum, Amsterdam

Rembrandt's 1656 painting of *The Anatomy Lesson of Dr. Deyman* was badly damaged by fire in 1723. All that remains today is a fragment of the original. This drawing shows the composition of the whole scene.

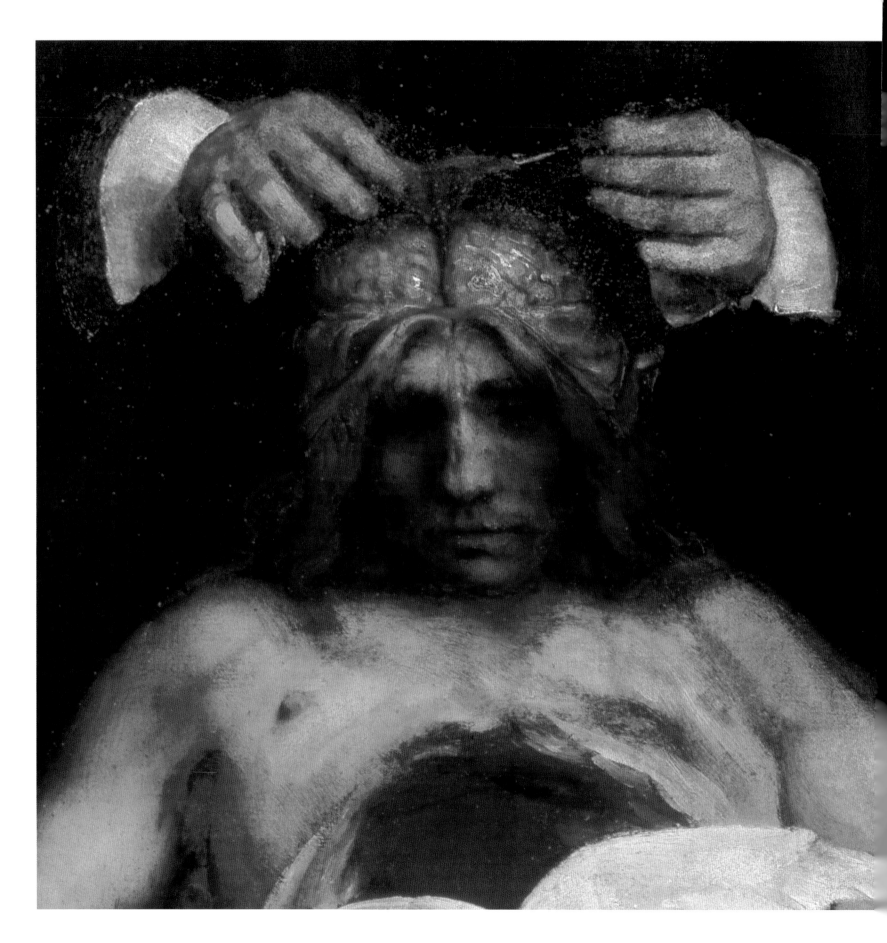

arrival in Amsterdam, and the rather nasty piece of work who was the unwitting subject was thus immortalised in a way he could never have imagined.

Not only is the Kid almost as much the focus of attention as the celebrated surgeon, but unusually for such pictures, Kindt's face is nearly as recognisable as that of the good Doctor Tulp (who had paid for the privilege). It might just as well have been called *Portrait of a Villain*. Or *A Morality Tale*.

Rembrandt did, however, make a couple of concessions to the sensibilities of his audience. The Kid's right hand had long been removed as a punishment for robbery, so Rembrandt thoughtfully replaced the stump with someone else's hand. Unfortunately, he made a small mistake – he gave Kindt fine fingers, a well cared for hand, not at all the sort of thing one would expect to find on the arm of such a man. And he made the Kid's other arm the target for the surgeon's knife rather than his stomach, which would in reality have been cut open first and the intestines laid out for inspection.

Rembrandt showed no such finesse twenty or so years later when he was asked to paint another anatomy lesson, that of Tulp's successor Dr. Joan Deyman. The corpse on that day was Joris Fonteijn.

Black Jack, as he was known, had been caught robbing a house in broad daylight and had knifed a man who tried to stop him. He was hanged on January 28, 1656, and his mutilated body painted by Rembrandt in every lurid detail. Not only had his insides been emptied out, but the top of his head had been peeled back like an orange and his brain parted down the middle like hair. It is not a pretty sight. But Dr Deyman seemed pleased enough, and for years the picture hung alongside the anatomy lesson of Dr. Tulp in the headquarters of the Surgeons' Guild in Amsterdam.

Bodies for dissection were hard to come by in those days and it was not unusual for a criminal who had been executed to end his days being cut up in front of an audience of grand doctors and the frankly curious. This sort of thing had been going on in Europe for years. Leonardo da Vinci opened up some thirty corpses himself so that he might learn about human anatomy.

In Amsterdam in the seventeenth century such events usually took place in winter when the temperature was low enough to allow the session to go on for several days without the spectators having to put up with the smell of a putrefying corpse. Dr. Deyman's lesson, being in January, was able to go on for three days.

In Leiden public dissections were treated as theatre, with spectators stacked high on the steep tiers that surrounded the surgeon's table. People brought food and drink and came and went at will. Dogs were allowed in, so long as they sat quietly. Children were not. Tickets were sold together with little bunches of sweet smelling herbs to hold under the nose, and anyone who pocketed one of the vital organs as they were passed round for inspection was fined several guilders and roundly rebuked.

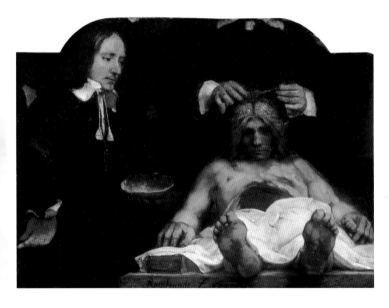

The Anatomy Lesson of Dr. Deyman, 1656 (detail)

Oil on canvas
Amsterdams Historisch Museum, Amsterdam

The middle aged Rembrandt was rather less concerned about the sensibilities of his public. Now, twenty years after his first anatomy lesson, he chose to show that of Doctor Deyman in all its gory detail, even the brain being exposed like an orange being peeled.

←

The Anatomy Lesson of Dr. Deyman, 1656

Oil on canvas
Amsterdams Historisch Museum, Amsterdam

↑

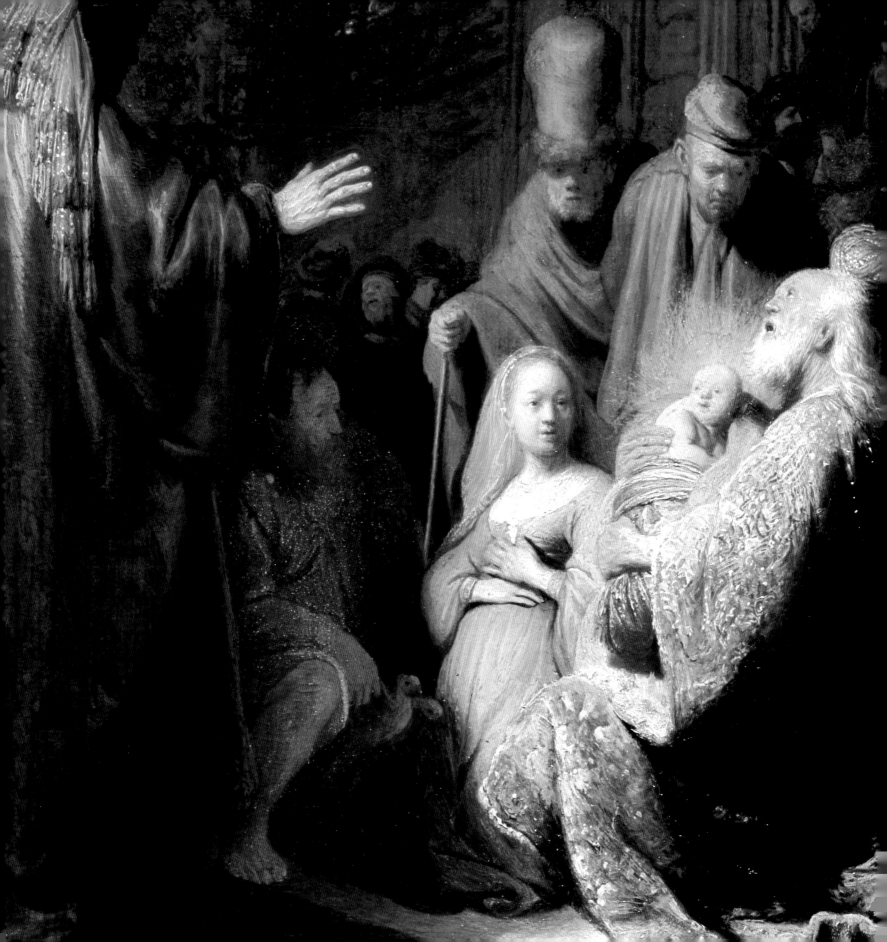

Light

There's an apocryphal story (one among many) that began circulating sometime in the nineteenth century and has been doing the rounds ever since. It is supposed to reveal the secret of the origin of Rembrandt's spectacular use of light.

The boy Rembrandt (so the story goes) spent much of his childhood in his father's mill. It was, as is the way with mills, tall, narrow, round and, above all, dark. A place of deep shadows. A solitary window set high in the circular walls casts a shaft of daylight in the gloom. And so, sitting beneath the axle of the groaning sails, the young artist fills his notebook with sketches according to what he sees. The silhouette of hand, a foot, an eye caught in single ray. A mote trapped in a sunbeam. A spotlight in the darkness. Modern scholars dismiss the story as a piece of mythology that has flourished with the seemingly inescapable popular need to romanticise the lives of great men.

Light was Rembrandt's element. No matter whence its inspiration. The words Rembrandt and light have a natural symbiosis; the one not thinkable without the other. They do say it was Leonardo who invented the dramatic effect of light and shade in art known as *chiaroscuro,* that it was Caravaggio who made it spectacular, and Rembrandt who gave it magic. And humanity.

At a distance of four hundred years, it is hard to imagine the quality of light in the days before electricity. No street lamps, no distant glow on the horizon of a great city. Rooms simply lit with tallow and with oil, rich in shadow and sharp in contrast. Images in a studio softened in the blur of candlelight. The dramatic counterpoint of night with day.

Rembrandt's sitters study weighty tomes not because they are great scholars – his mother was, in fact, illiterate. In Rembrandt's world the pages of a book are a source of light; they illuminate the face bent to read it; a penitent woman is bathed in the glow of her redemption, a dead man lit by the miracle of his resurrection.

Rembrandt's light is both metaphorical and real. He called it 'sparkle' and he cherished it. 'Hang this picture in a bright light and in such a manner that it can be viewed from a distance. It will then sparkle at its best.' Thus Rembrandt wrote to Huygens in a letter, dated 27 January, 1639, which accompanied the last of his paintings to go to Frederick Hendrick from the original commission.

In the view of modern scholars, Rembrandt's *sparkle* owes more to the magic of his astonishing mind and the example of Caravaggio than to the influences of his childhood.

His contemporary critics looked at the thickness of his paint that artists call *impasto*; they noted the way in which clots of paint were piled upon clots of paint until the rough

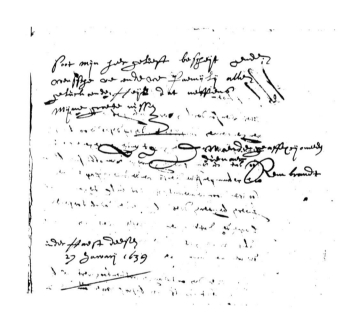

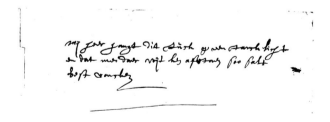

Letter from Rembrandt to Constantijn Huygens, July 27, 1639

National Archive, The Hague

When he had nearly finished the commission of a series of paintings for Frederick Hendrick,

Rembrandt dispatched the latest work to the Prince's Secretary, Constantijn Huygens, with the request to: *Hang this picture in bright light and in such manner that it can be viewed from a distance. It will then sparkle at its best.*

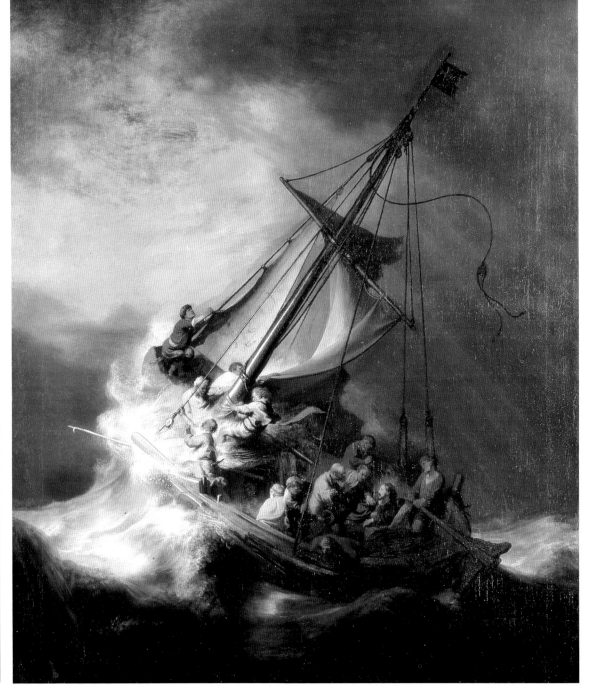

The Presentation in the Temple, 1631

Oil on panel
Royal Cabinet of Paintings Mauritshuis,
The Hague

Christ in the Storm on the Sea of Galilee, 1633

Oil on canvas
Isabella Stewart Gardner Museum, Boston

Ecce Homo, 1634

Oil on paper glued to canvas
National Gallery, London

A rare preparatory study for
an etching.

←

The Stone Bridge, c. 1637

Oil on panel
Rijksmuseum, Amsterdam

↓

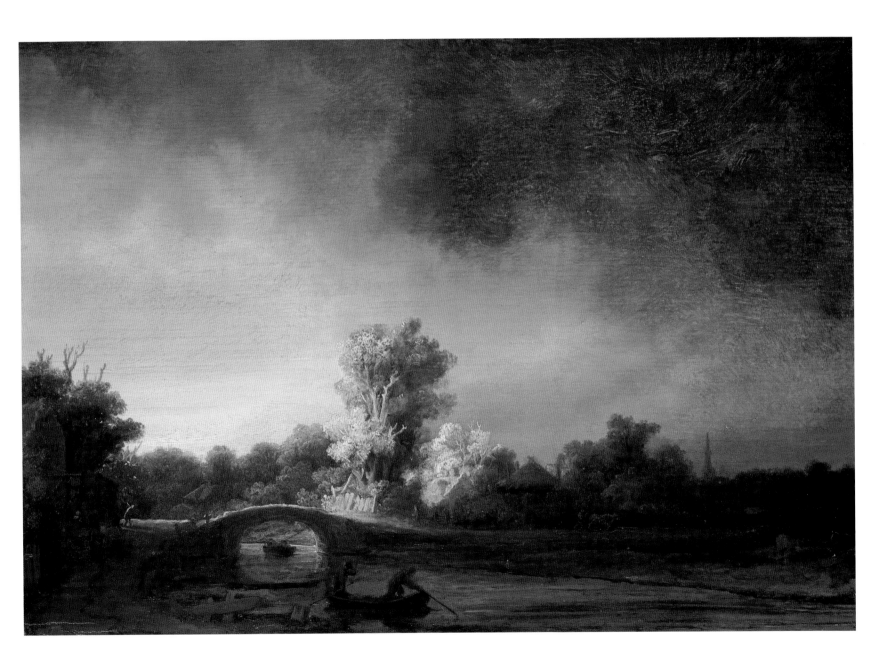

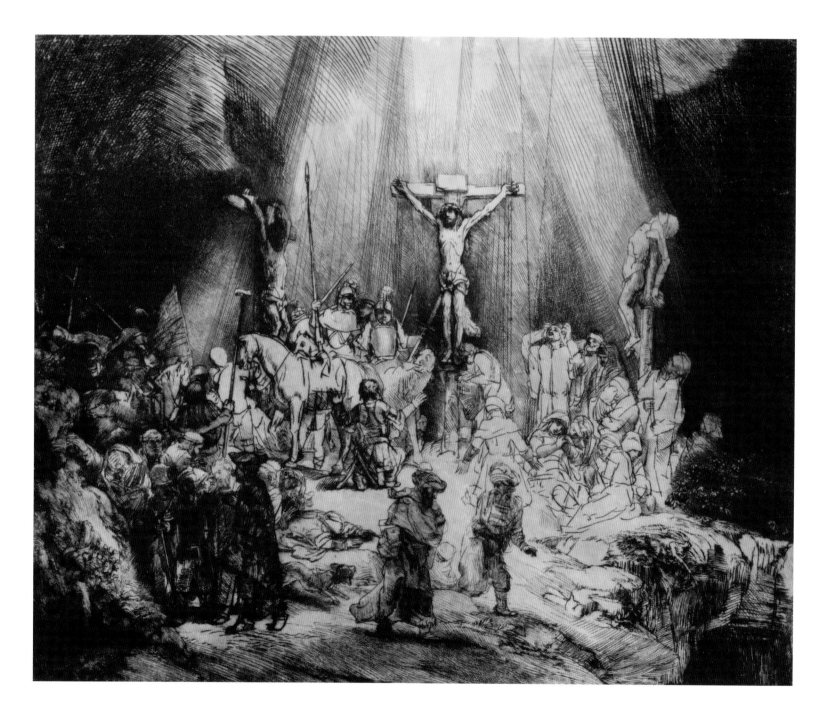

Nowhere was Rembrandt's brilliant use of light more dramatically displayed than in his numerous states of the print *The Three Crosses*. And although, over a period of many months, he made a number of changes – scratched straight on to the plate with drypoint and burin – in each of the several versions it is the same 'shining light that cleaves the darkness that fell over the earth' that illuminates the moment. There is, of course, the usual cast of characters to fill the stage, but it is the figure of Christ in death that tells the story. In human terms, in Rembrandt terms.

The Three Crosses, 1653, first state

Drypoint and burin
Rembrandthuis, Amsterdam
↑

The Three Crosses, 1653, fourth state

Drypoint and burin
Rembrandthuis, Amsterdam
→

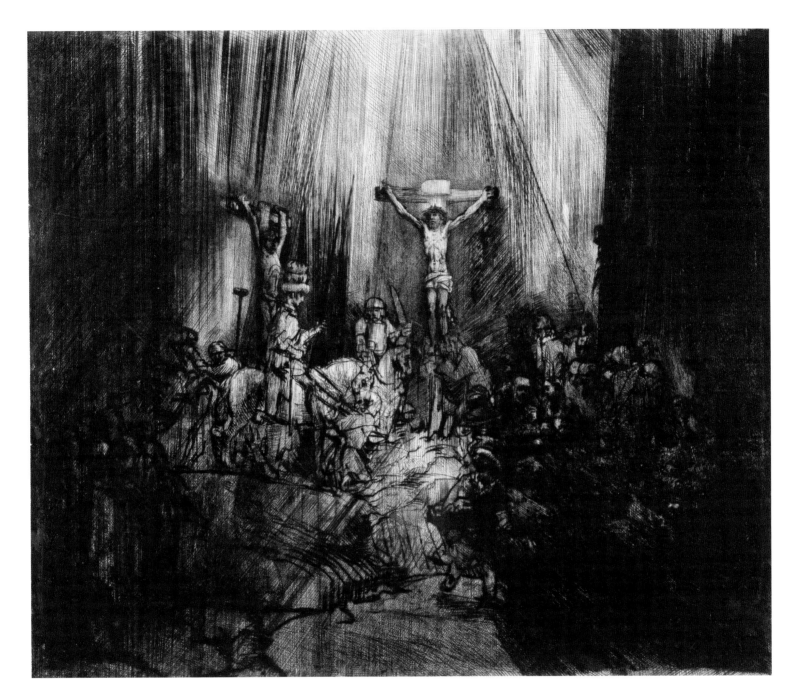

surface took on a three dimensional quality and literally sparkled with refracted light, and they decided it was too much. It broke too many rules.

One said his colours dripped like dung down the canvas while another insisted that the paint was so thick that 'when you examined the pictures closely they looked as if they had been made with a bricklayer's trowel.' And his portraits, well, they were something else again: 'If you laid a Rembrandt portrait flat on the ground, you could pick it up by the nose.'

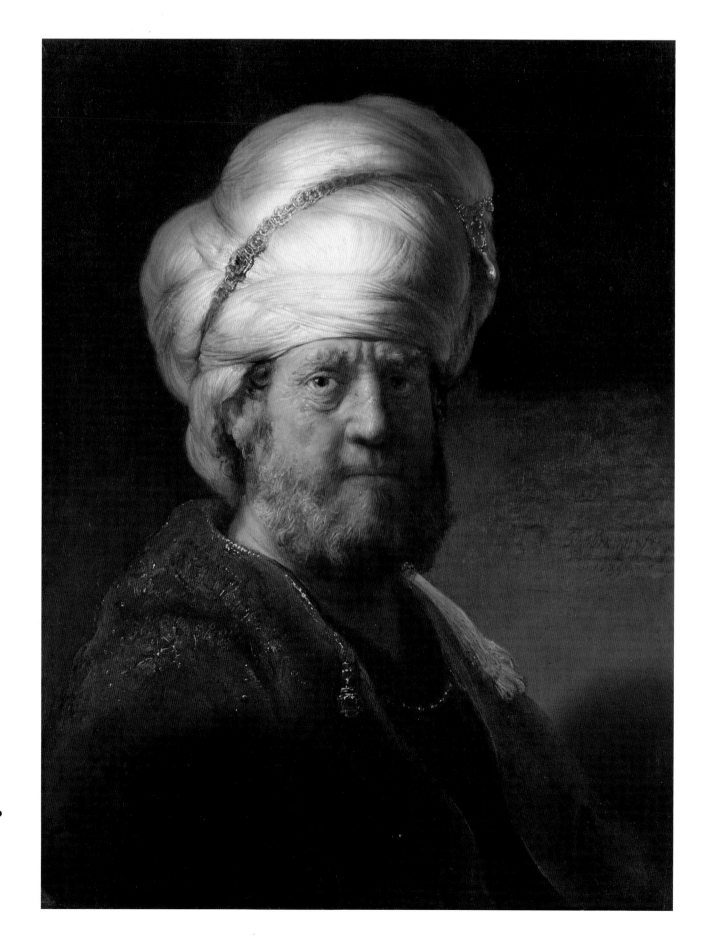

Rembrandt was an inveterate collector of things. All sorts of things. Things that could appear eventually in a picture. Things that would sit on a shelf in his *kunstkamer* or private museum for no better reason than that they might come in useful one day. He had helmets and hats and feathers and plumes and pebbles and cushions and carpets and busts and bronzes and stuffed birds and teapots and even the remains of a human arm in formaldehyde. He had the death mask of a former Prince of Orange and a box full of ears and noses cast from life and a harp that was probably not the one that David played for Saul, as that was a thing of Rembrandt's fancy.

He had thirteen bows and arrows, a Croatian helmet and an old fashioned powder horn. He had thirty-three antique hand weapons, a selection of wind instruments and a stuffed bittern that may well have been the bird that stole centre stage from the huntsman in a picture made in 1639. He had a picture of three little dogs by his son Titus and paintings by Lievens and Lastman and Van Eyck and Van Leyden and one by Raphael which might or might not have been the real thing. He had prints and drawings by Bruegel and Brouwer and Dürer and Van Dyck, not to mention Rubens and Titian and Michelangelo.

He had a lump of coral, a quantity of antlers and a bust of Homer that was probably the one that Aristotle contemplated in a painting he had shipped to a buyer in Sicily. He had a lion skin and a small model of a metal cannon. He had walking sticks and swords and gourds and bottles and baskets and busts of all the Emperors of Rome. And, in a corridor were noted 3 men's shirts, 6 handkerchiefs and a few collars and cuffs. Such was the detritus of one man's life.

Over two long days in July 1656 were itemised bits and bobs and odds and ends that to a clerk, to a methodical man, to someone who had not experienced the heady delight, the intoxication of the gathering together of such a cornucopia of ornament, might have seemed more like a silly indulgence. Or an addiction.

At auctions Rembrandt 'bid so high at the outset that no one else came forward to bid', according to an Italian writing only a few years after the artist's death. 'And here he acquired clothes that were old-fashioned and disused as long as they struck him as bizarre and picturesque, and those – even though at times they were downright dirty – he hung on the walls of his studio among the beautiful curiosities he also took pleasure in possessing.' And years later, when he had decamped with his little family and Hendrickje's heavy oak chest from the vestibule (which she had to go to court to keep from the vultures), he started all over again on the Rozengracht.

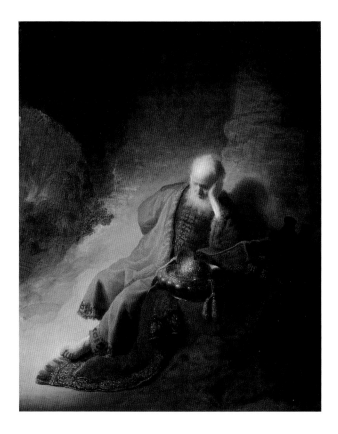

A Man in Oriental Costume, 1635

Oil on panel
Rijksmuseum, Amsterdam

'(...) he acquired clothes that were old-fashioned and disused as long as they struck him as bizarre and picturesque (...)'
←

Jeremiah Lamenting the Destruction of Jerusalem, 1630

Oil on panel
Rijksmuseum, Amsterdam

Jeremiah with precious objects that might or might not have been part of Rembrandt's own private museum and sold, along with the rest of his collection, at the height of his money troubles.
↑

The reconstructed art cabinet
at Rembrandt's house in the
Breestraat.

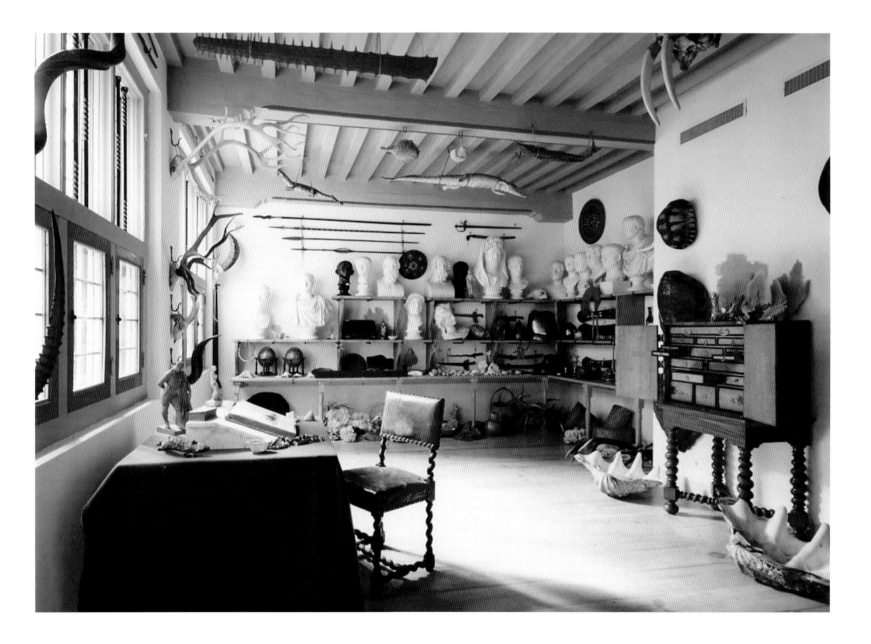

Artist Drawing from a Model, c. 1639

Etching and drypoint
Rembrandthuis, Amsterdam

Rembrandt's studio, with a piece of sculpture from his collection on the mantelpiece.

The Shell (Conus Marmoreus), 1650

Etching, drypoint and burin
Rembrandthuis, Amsterdam

The only still life-etching Rembrandt ever made. Exotic shells were precious collector's items in Rembrandt's days. This one may have been part of his own collection.

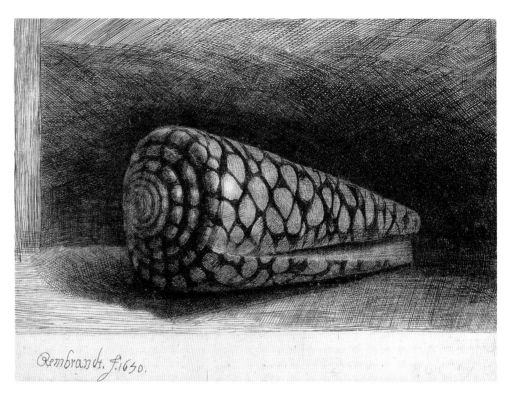

Whatever the reason, whether it was love or compulsion that made Rembrandt a collector, when matters came to a head and the pressure from his creditors forced him to put the things in his private museum up for sale, it took assessors (who charged 8 guilders a day) many hours to complete the inventory – 363 items, each one meticulously listed by hand in a document that is preserved to this day in the Amsterdam Municipal Archive.

Two hundred or so years after Rembrandt's death, another Dutch artist, Vincent van Gogh, took pains to make a small pilgrimage to Rembrandt's home in Amsterdam. 'I finally found the house in the Breestraat where Rembrandt lived', he wrote to his brother Theo in 1877. Van Gogh would have had no such trouble today. The Rembrandthuis stands on the very spot, with the same entrance hall, the same studio, even the same (or similar) bed in which Saskia died. There, too, is recreated the artist's *kunstkamer*, or one very like it, with helmets and heads and hats and harps and all the eccentricities of the original, gathered together in the old house by curators whose affection for the art of collecting might well have been borrowed from Rembrandt himself.

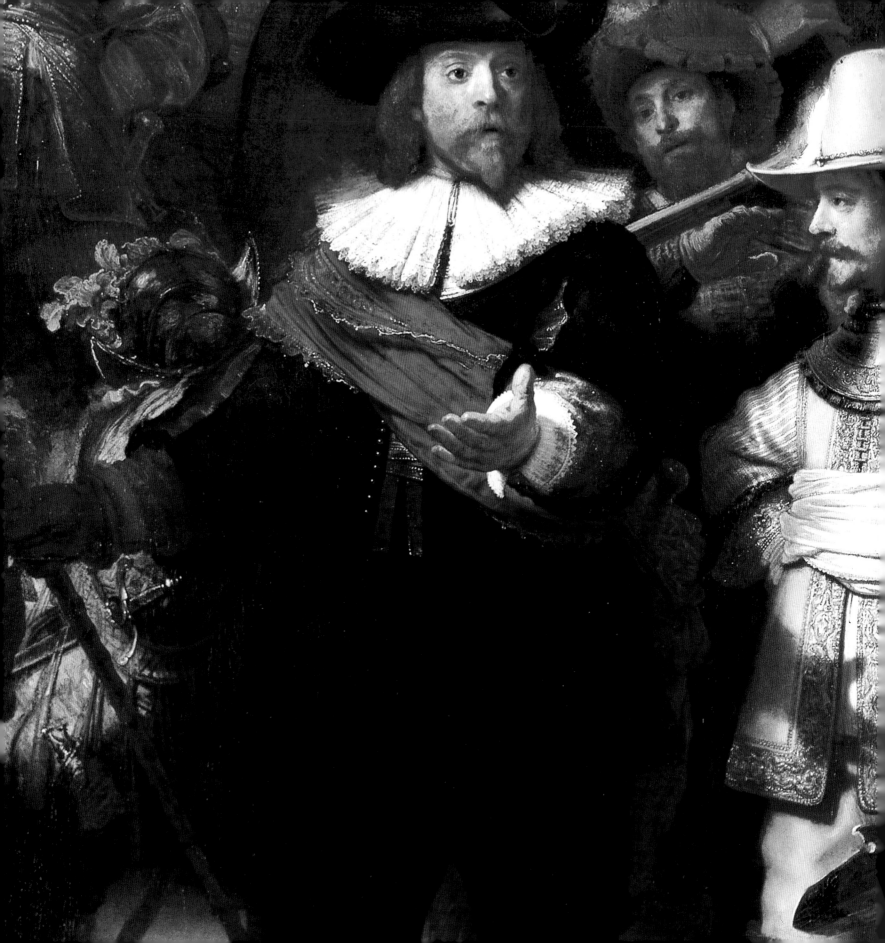

Night Watch

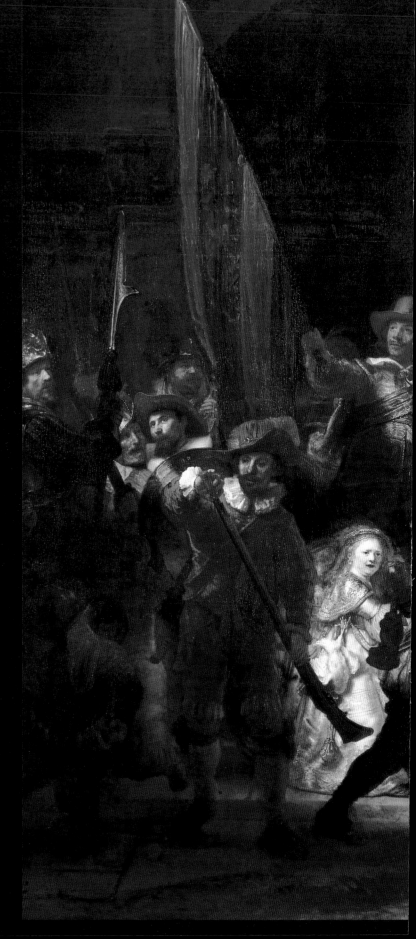

The Night Watch, 1642

Oil on canvas
Rijksmuseum, Amsterdam

Despite the fact that Rembrandt's acknowledged
masterpiece, *The Night Watch*, was widely
admired, according to his erstwhile student
Samuel van Hoogstraten 'in the opinion of many
he went too far (...) making more work of the
image as a whole (...) than of the individual
portraits he was commissioned to paint.'

In other words, once again, Rembrandt had
defied the artistic conventions of the time. As
with Doctor Tulp's anatomy lesson, he had done
his own thing, in his own way.

'But, however much it may be reproved,'
Hoogstraten added, 'this work will survive all its
rivals because it is so painterly in conception (...)
and so powerful that (...) all the other paintings
[in the hall] are like playing cards.'

Praise indeed from a critical former student
writing in his own 'how-to' instruction book for
budding artists. Hoogstraten, though, could not
leave well alone. He had to add a few words of
personal criticism: 'Although I would have
prefered it if he would have put more light
into it.'

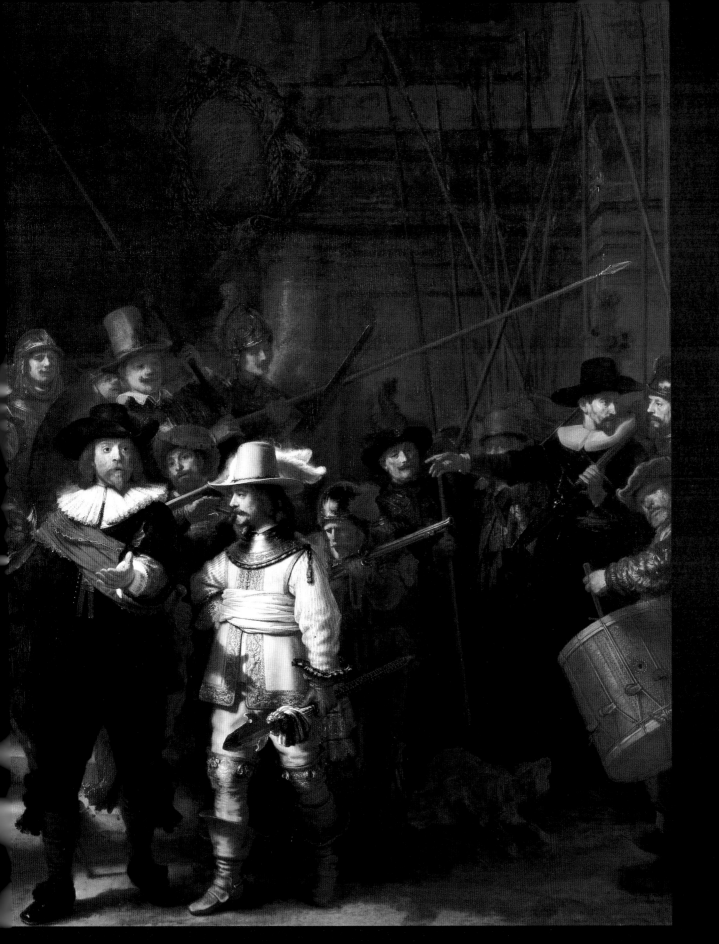

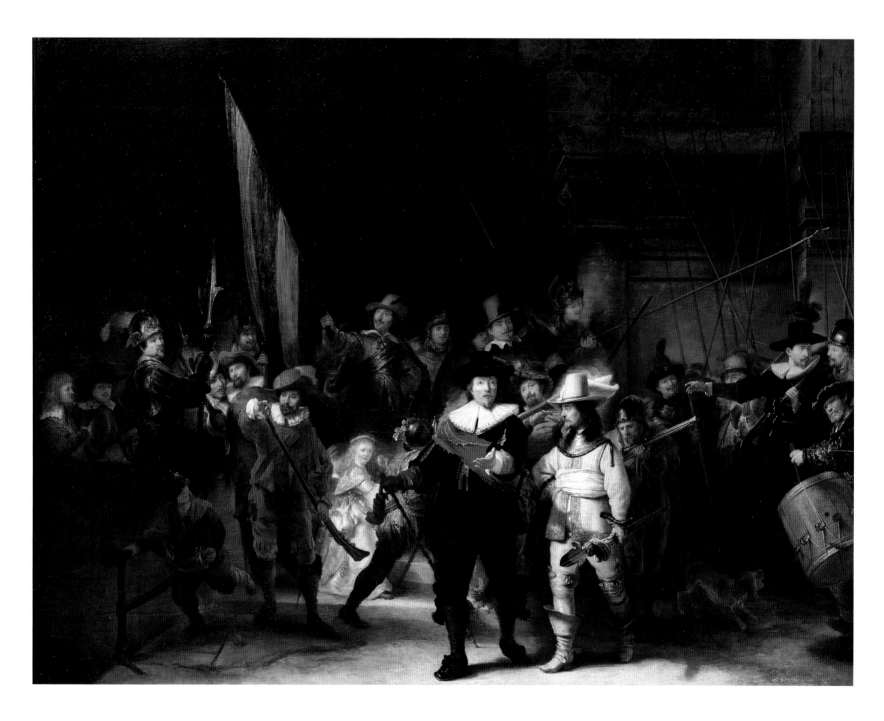

Gerrit Lundens, *The Night Watch* (*small size copy after Rembrandt*), c. 1650

Oil on panel
Rijksmuseum, Amsterdam

Had it not been for Captain Banning-Cocq's decision to have a copy made of the iconic painting, no-one would have known exactly what and how much was trimmed from the original when it had been moved to Amsterdam Town Hall at the turn of the eighteenth century.

Rembrandt's monumental painting, *The Night Watch*, is not so much an icon of Dutch art. It is *the* icon of Dutch art. In the three hundred and more years since it was painted, this one picture has had more adventures than a whole gallery of treasures. It has been fêted and reviled, vandalised, slashed and burned with acid. It has been trundled up a road, hauled through a window, sailed down a canal, rolled up in a cylinder, hidden in a castle, buried in a cave, drenched in water and has had bits lopped off it.

When Rembrandt painted it, group portraits were all the rage. It was commissioned by Captain Frans Banning-Cocq and his company of part-time musketeers whose duties had less to do with the defence of the city, more with parading about at public ceremonies. In those days, the fashion was to paint the militia dressed in their finery, all lined up in a neat row and looking very important.

Rembrandt, of course, did no such thing. He turned the picture into a great drama in which the Captain and his merry men (who had all paid 100 or so guilders to be in the frame) were about to embark on their rounds of the city. He even added a supporting cast of extras to send them on their way. They might just as well have been going off to war so infectious is the excitement.

Just as Rembrandt had turned Doctor Tulp's anatomy lesson into a piece of theatre, so *The Night Watch* became not simply another group portrait but a scene from life. It hung, undisturbed, in the headquarters of the militia for 70 years until at the turn of the eighteenth century it was moved (all 337 kilos of it) to Amsterdam Town Hall. When it arrived it was discovered that the canvas was too big to fit on the wall, between two doorways, where they wanted it to go. So instead of hanging it somewhere else, it was decided to cut it down to size. Literally. Had it not been for Captain Banning-Cocq's decision, years before, to have a copy made, no-one would have known what was missing – a great chunk from the left side.

Autumn, 1939, found it hanging in the Rijksmuseum where it had been since the grand opening in 1885. Now fear of invasion led to it being taken from its frame, loaded onto a truck and driven under armed guard into the flat Dutch countryside, where it was stacked away with other treasures in a fortified castle. Then came the enemy, trundling into the Netherlands with their tanks and their heavy artillery and their acquisitive generals. Once again, *The Night Watch* was loaded onto a truck and driven in utmost secrecy to the north sea coast, where it was buried in deep vaults under the sand dunes. On the way it spent a night in a blacksmith's shed, another on a boat in a storm. When it arrived it was too large to go through the entrance and had to be taken off its stretcher, outside in the wind and the sand, and rolled around a metal cylinder for safe keeping. Until the dunes became unstable, that is, when it was moved again, this time to a bomb-proof safe in a catacomb of caves in a hill near Maastricht – and there it stayed for the next three and a half years.

Restored to its former glory in postwar Amsterdam, *The Night Watch* now became prey to a series of extraordinary attacks. First came a man who thought the Captain in his fine black uniform was the devil and slashed at him in twelve places with a carving knife. It took a team of expert restorers eight months to repair the chunks of canvas that had been ripped out of the sergeant's jacket.

After that *The Night Watch* was given its own security guards – not that they were able to stop a 'man out of his senses' from spraying it with acid. But they were close enough to drench the picture with gallons of water so that the acid reached no further than the varnish.

Somehow, the great picture has come through it all none the worse for wear. It stands still as a kind of altar piece to Dutch art in the vaulted temple of the Rijksmuseum in Amsterdam, a magnet for more than a million visitors a year.

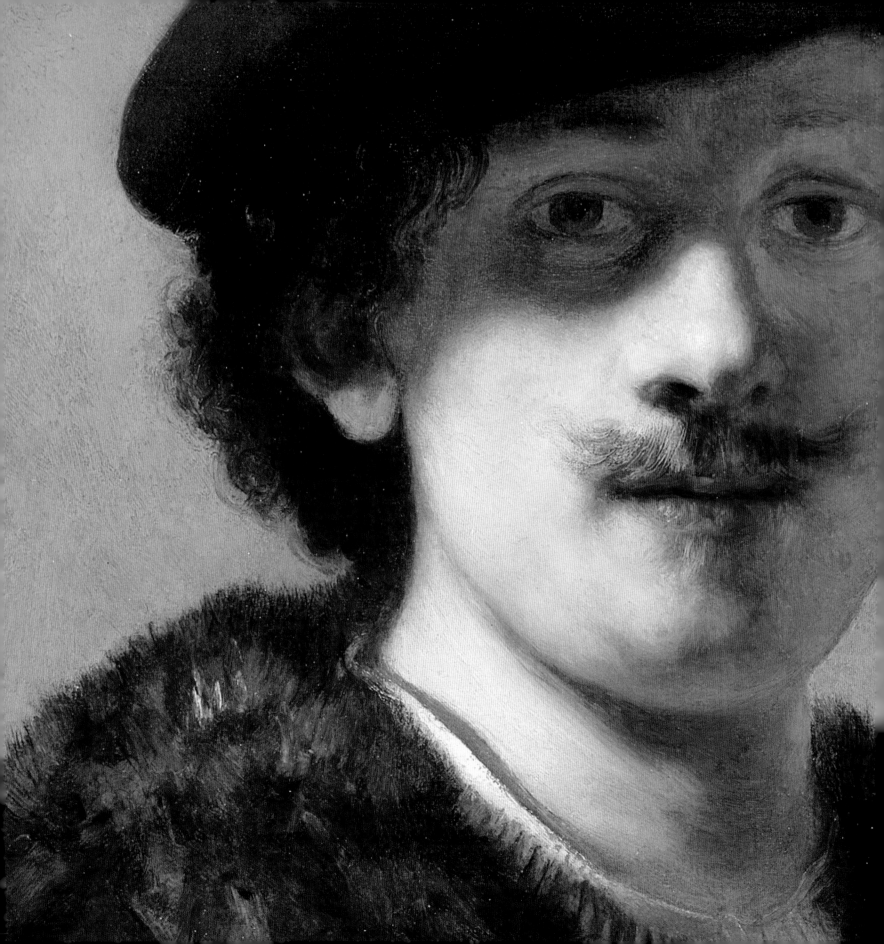

Over-painting

It is hard to believe, looking now at the painting that Frenchman Paul Page bought at auction in Paris in 1956, that it cost him just £220 – in today's money that is. Admittedly there was something rather queer about it and nobody – except Monsieur Page – thought it was anything very special.

Back in 1935, when it had first been photographed, it was described as the portrait of a Polish aristocrat by an unknown artist: a curious study of a nobleman with curly hair, a tall red hat, exotic moustaches and pearl earrings. But since then, the owner of the time had removed quite a few of the trimmings, revealing a man in a beret.

The 1956 sale room catalogue described the result as '*after Rembrandt, his portrait by himself.*' – although no-one there seriously believed it had been anywhere near the Dutch master. One of the experts in the sale room described it as 'a charming fake'.

But it was not the picture itself, not the portrait of the Polish or Russian or German or whatever nobleman, that interested Monsieur Page. It was the belief that this was simply an overpainting – one portrait painted on top of another. And the suspicion of what might be underneath was what excited him. He was sure that he could detect something of the master's touch around the eyes. He tried removing a few more details, and the more he took off the more intrigued he became.

Over the years that followed he consulted a whole bevy of different scholars until, finally, in 1995 someone suggested he might show the picture to an international expert – which is how it came to the attention of Prof. Ernst van de Wetering, Chairman of the Rembrandt Research Project.

The wisdom of completely removing the overpainting was discussed at great length. It is not something that conservators are wont to do and Martin Bijl, former Head Conservator of the Rijksmuseum in Amsterdam, who was quickly brought into the team, was certainly in no hurry to do anything of the kind. 'This is something we never do,' says Prof. van de Wetering. 'But we did it in this case because so much had been removed already. Otherwise we would never have done it.'

Tests already made on samples of paint showed that the overpainting was very old and it began to seem possible that both top and bottom layers might have been made in the seventeenth century. Someone suggested that it might have been the work of the Dutch master Govert Flinck, who had once been an assistant to Rembrandt, but the Flinck experts didn't want it in their man's *oeuvre*.

There were x-rays and infra-red tests and consultations and examinations and paint analyses and talk and thought and more talk until, finally, slowly, painstakingly, meticulously, layer by layer, little by little, the top layer of paint was removed and the original picture came into view. It took them all of three years, with interruptions, to complete the job.

The answers when they were revealed were more astonishing than would have been sensible to hope – and gave the art world a newly discovered Rembrandt original. A Rembrandt self-portrait, dated 1634 and signed while the paint was wet.

And there was a bit of a bombshell, too, in the story behind the hidden work: in all probability it was Rembrandt himself who told an assistant, or even a student, to cover his own portrait with something more saleable. There was a variable market, in the seventeenth century, for portraits of artists of themselves, but if one remained unsold for too long it became outdated.

And so Rembrandt (who by all accounts was not precious about his work) would tell an assistant to turn the unwanted portrait into something more attractive to a potential buyer – pictures of exotic aristocrats were quite the vogue at the time, in much the same way that the image of an Eurasian woman with a blue face, or a Neapolitan street urchin with a tear on his cheek, was a popular decoration for an English home in the late twentieth century. The result was a *tronie* – a face painting. Until the Dutch experts got to work on it three centuries later and found the hidden treasure beneath.

And so, in 2003, the heir to an unexpected Rembrandt took it to London where at public auction the picture that had last been sold for £220 was knocked down to an American property tycoon for nearly seven million pounds. It was the highest price in memory paid for a Rembrandt self-portrait and one of only three in private hands.

The original painting, a Polish nobleman, photographed 300 years after it was made, and before anyone had started removing the overpainting (c. 1935).

→

Photograph of the same painting after some of the overpainting had been removed by the owner (c. 1950).

→ →

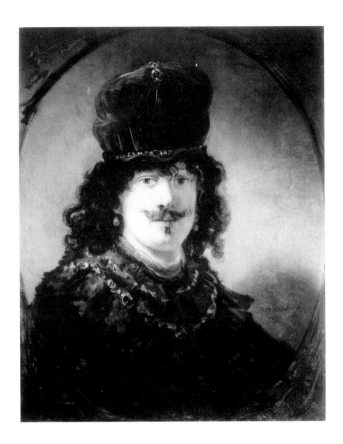

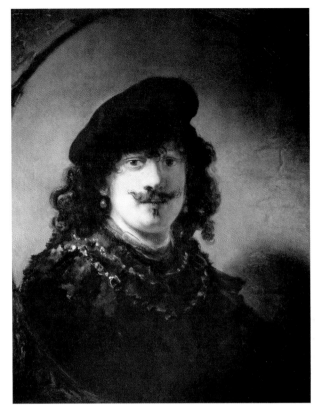

Photograph of the painting thirty years later when yet more of the overpainting had been taken off revealing more of the hidden Rembrandt self-portrait (c. 1980).

→

Self-portrait, 1634

Oil on panel
Private collection

No longer hidden, the original Rembrandt is finally revealed.

→ →

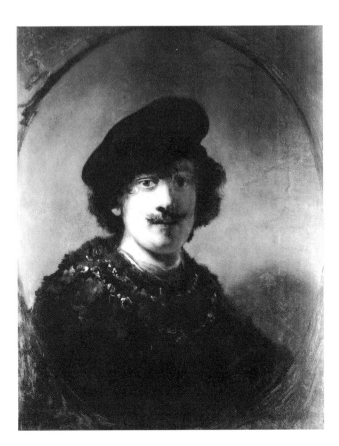

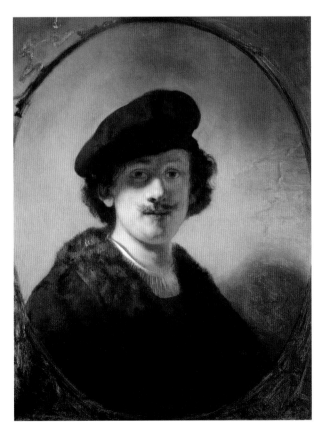

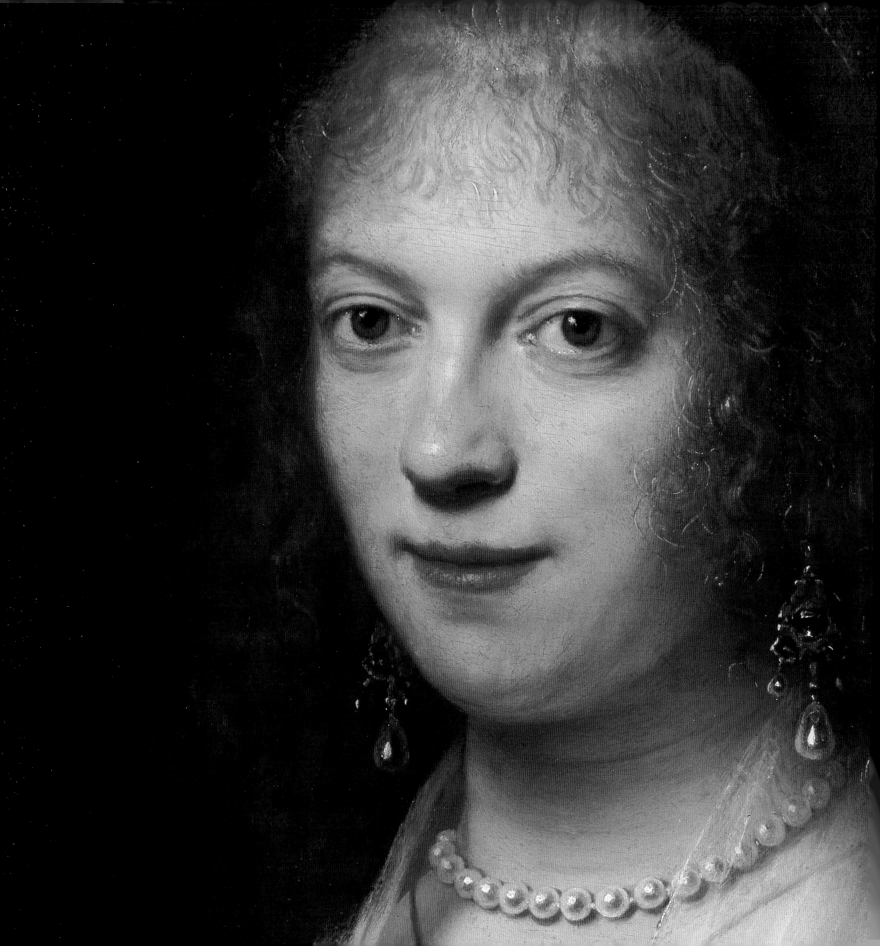

Portrait

In his day Rembrandt was considered a great portrait painter. He was much in demand. He earned top fees. He was famous. There was just one problem. His portraits didn't look much like his sitters. Or so it was said. No one can be sure of course, because the camera had yet to be invented.

But what few (save the most churlish) questioned, even in the days when Rembrandt was assailed by critics on all sides, is that he did great faces. Or what the Dutch called *tronies*: pictures of people that were not meant to be of anyone in particular: pictures that capture the spirit rather than the

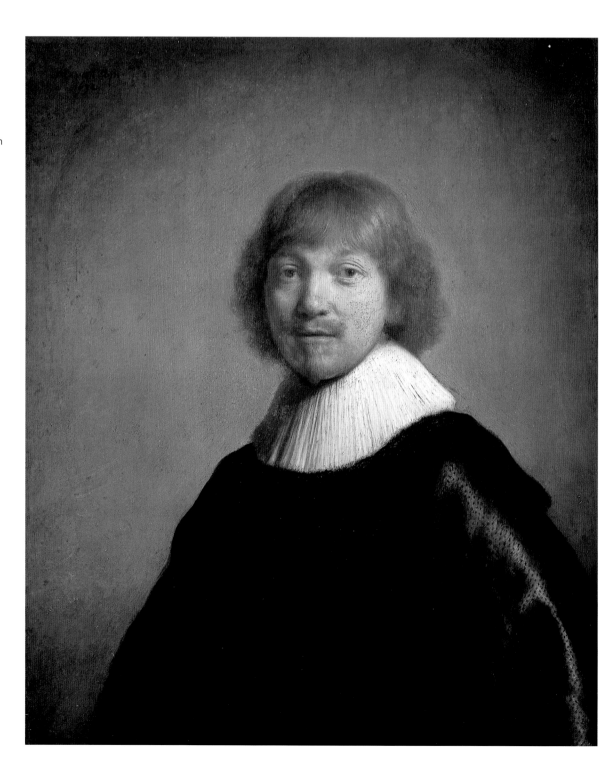

***Portrait of Jacques de Gheyn,*
1632**

Oil on panel
Dulwich Picture Gallery, London

The Rembrandt portrait mocked in verse by Constantijn Huygens as: *...it's not de Gheyn at all.*

superficial likeness. All is revealed, nothing camouflaged: the crudity of vanity, the pomposity of self-esteem, the bloom of youth, the flush of beauty, the crease of old age – pores, acne, wrinkles and flesh so true to life that to stand before a Rembrandt portrait is to smell the odour of bodies swathed in heavy clothes at a time when bathing was considered unhealthy.

These are portraits of real people, not sops to human vanity, which in Amsterdam in the seventeenth century wasn't exactly the idea. To have one's portrait painted was a

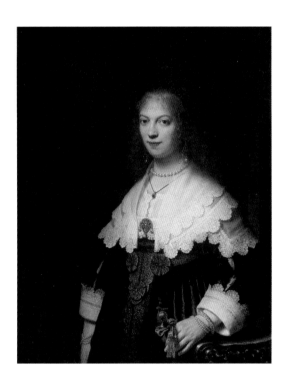

Portrait of a Woman known as 'Maria Trip', 1639

Oil on panel
Rijksmuseum, Amsterdam

The sitter of this beautiful portrait is no longer identified as Maria Trip.
↑

Portrait of Amalia van Solms, 1632

Oil on canvas
Musée Jacquemart-André, Paris

Rembrandt's portrait of Amalia van Solms, wife of the Prince of Orange, was an important commission. But when it was finished they hung it in a corridor 'between two galleries'.
→

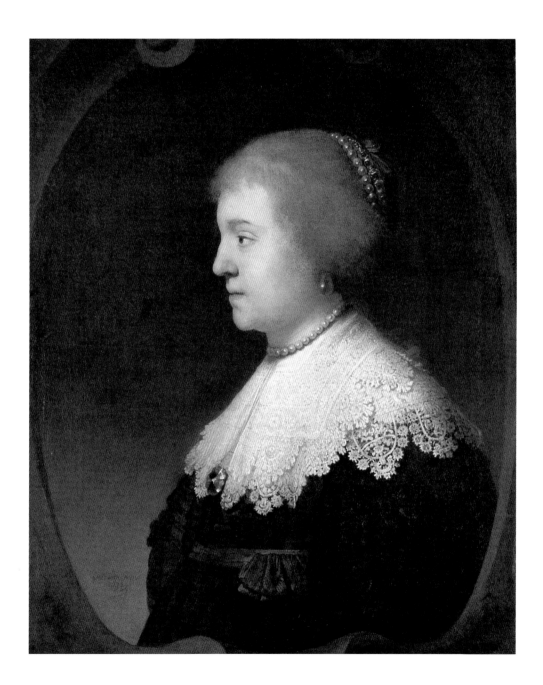

Old Man in Profile, 1630

Etching
Rembrandthuis, Amsterdam

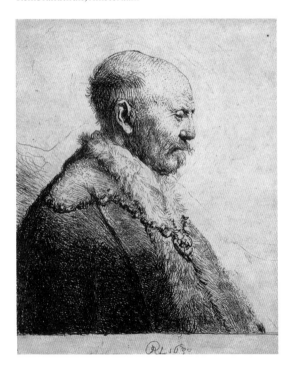

Old man with a Beard, c. 1631

Etching
Rembrandthuis, Amsterdam

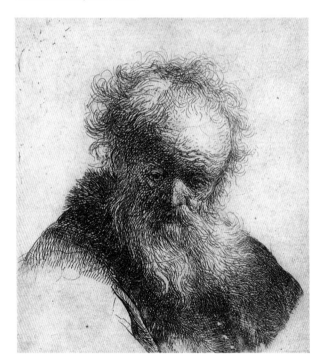

symbol of status. And the greater the reputation of the painter, the greater the glory reflected upon the sitter.

It worked the other way too. The standing of the sitter conveyed honour upon the painter, so that an artist's excellence might be judged by the importance of his subjects. Thus, it was a little triumph for Jan Lievens to paint Constantijn Huygens, Secretary to the Prince, but it was even better for Anthony van Dyck to be commissioned to do Frederick Hendrick himself.

When Rembrandt was asked to paint Amalia van Solms, the wife of the Prince of Orange, that was quite a coup too. Except that when it was finished they hung it in a corridor 'between her two galleries' because (it was said) she did not

think it looked much like her. Perhaps it didn't. Or perhaps it did and she didn't like what she saw. Her hair is just a tad on the thin side, her nose a trifle red.

In his first four years in Amsterdam, Rembrandt was greatly in demand. For fifty months he painted a portrait a month. Then, in 1633, Rembrandt's erstwhile champion, Constantijn Huygens who, quite apart from being an art lover was considered the greatest Dutch poet of his day, wrote a series of barbed verses (in Latin, of course) about a portrait that didn't look much like the sitter. It was called: 'Squibs on a likeness of Jacques de Gheyn that bears absolutely no resemblance to its model'.

Portrait of the Preacher Johannes Wtenbogaert, 1635

Etching, drypoint and burin
Rembrandthuis, Amsterdam

Portrait of the Preacher Jan Cornelis Sylvius, 1633

Etching
Rembrandthuis, Amsterdam

The poem ended:

> *The hand is that of Rembrandt,*
>
> *the features are de Gheyn's.*
>
> *Admire it, reader, though it's not de Gheyn at all.*

Huygens did not actually publish until 1644, at which point he left out the bit with Rembrandt's name. By that time, though, everyone knew whom he meant.

Rembrandt, meanwhile, had given up doing portraits. He had stopped abruptly and for no obvious reason. For ten years he painted none at all. When he did resume, he did a portrait of the enormously powerful Andries de Graeff. The agreed price was 500 guilders, which was Rembrandt's usual charge for a full length work. For a couple it would have been 800. When the time came, Andries de Graeff refused to pay.

He gave no reason. Rembrandt had to sue for his money. The case went to adjudication, and his old business partner Hendrick Uylenburgh was one of the jury who had to decide the outcome. They found in Rembrandt's favour; or rather, they passed no judgement on the portrait, simply said that since De Graeff had agreed the fee, he should pay it. Their decision did nothing for Rembrandt's reputation.

In later years, one historian has suggested that the reason Andries de Graeff went off the idea of having his portrait done by Rembrandt had less to do with whether the artist 'had produced a clear likeness', more with the fact that Frederick Hendrick had new favourites now. If the Prince of Orange was not commissioning his pictures from Master van Rijn, there was no longer a social *cachet* to be had in his patronage.

Quest

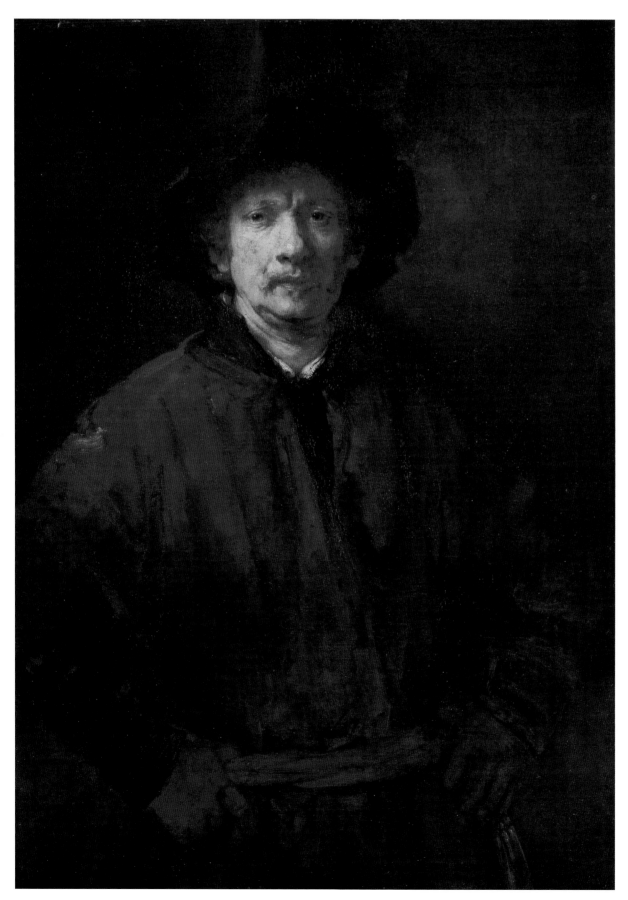

Self-portrait, 1652

Oil on canvas
Kunsthistorisches
Museum, Vienna

An astonishing, unforgettable self-portrait that Ernst van de Wetering calls the work of 'the late, *great* Rembrandt.'

The Jewish Bride, c. 1665

Oil on canvas
Rijksmuseum, Amsterdam

'A quest for a spectacular effect, an emotion, a sparkle in the paint, a focus on a sleeve...'

The Holy Family, 1645

Oil on canvas
Hermitage, St. Petersburg

The beginning of the 'late, *great* Rembrandt'.

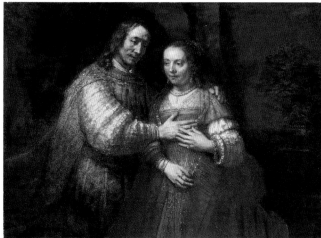

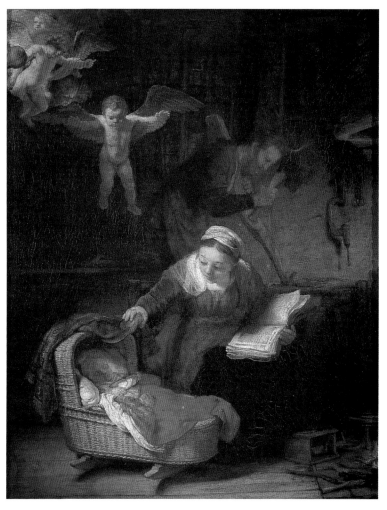

The life of Rembrandt is riddled with myth and mystery and misconception, probably because it all happened so long ago and so few documents have survived down the centuries. It is not the early years that are a puzzle. Then he was young and noisy and his prodigious talent separated him from the *hoi polloi*. People bought his pictures and talked about him and lauded him in verse. In those days his amorous adventures attracted the censure of the church and his financial problems brought him to the attention of the law. All of which are well recorded.

No, it is the later years that remain obscure and ripe for speculation. In such a way the legend of Rembrandt's lost years has grown: the mystery of why for ten years he painted not one portrait; the mystery of why, in that same decade he completed possibly ten, maybe twelve or even thirteen paintings. No more.

Popular myth has it that 'something terrible' happened to him in the early 1640s or thereabouts which sent him into a decline of sorts and led to years of obscurity and poverty. The story goes that it might well have been the death of his young wife, the much loved Saskia, and all those babies, that started

his depression; if such it was. Or the failure of *The Night Watch*. Except that *The Night Watch* was not a failure; it attracted criticism, it is true, which can have been no more than Rembrandt might have expected, given the innovative style of the great painting. It also attracted much praise.

But the tale, seeded by petty disapproval, sprouted in the nineteenth century and blossomed into full blown myth in

the twentieth. Modern thinking has it that, in truth, Rembrandt deliberately isolated himself. To a purpose. He had a quest. And if that sounds old fashioned, that's because it is.

It was, after all, four hundred years ago. When Rembrandt was born Queen Elizabeth I was newly dead, James I ruled England and Holland was at war with Spain. Shakespeare was alive and so was Caravaggio.

Much as the knights of old went questing, so did Rembrandt van Rijn. Except that his Holy Grail was not a cup nor a chalice nor an ark. It was something less tangible – an excellence, a purity, an effect. This was his quest. 'It is definitely true that there was something strange going on,' says Ernst van der Wetering, Emeritus Professor of Art History at Amsterdam University and himself an artist. 'For instance in the ten years after *The Night Watch* he did not paint one portrait. This was taken to mean that he did not get commissions any more, that suddenly he was out of favour because of the rejection of *The Night Watch*. This is the myth. But the other side of the story is that this was the beginning of the late *great* Rembrandt. The real, deep, feeling Rembrandt.'

Bob van den Boogert, Curator at the Rembrandthuis in Amsterdam, believes wholeheartedly in the Rembrandt quest. 'All his life he was searching for something. He never stopped. It was a process of trial and error. A quest, for a spectacular effect, an illusion of three dimensions, an emotion, a sparkle in the paint, a focus on a sleeve, always exploring, never the conformist. These days all this would be a claim to fame, the ultimate proof of an independent turn of mind. But then...'

All of which leads to one of the great mysteries in art

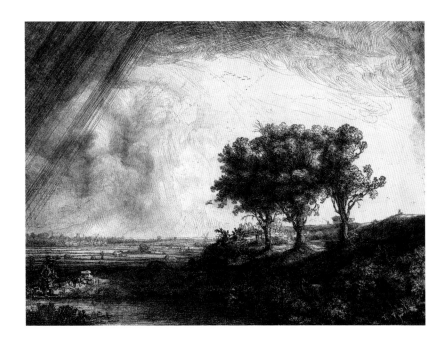

The Three Trees, 1643

Etching, drypoint and burin
Rembrandthuis, Amsterdam

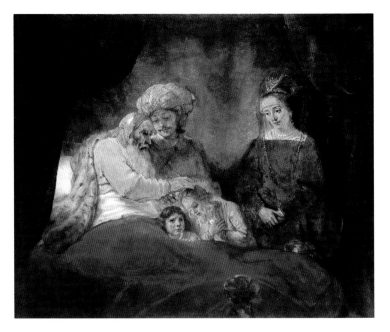

Jacob Blessing the Sons of Joseph, 1656

Oil on canvas
Gemäldegalerie, Kassel

history. In 1659, when the city fathers were looking for the best man to paint a series of monumental paintings for the fine new Amsterdam Town Hall, it was Govert Flinck who was chosen. Not Rembrandt, but Flinck. An establishment man. A conformist. A man who had deliberately sought out Rembrandt as his teacher so that he might absorb his style.

And when Flinck unexpectedly died before the job had gone much beyond preliminary sketches, it was felt by the worthy burgers that a total of five artists would be needed to complete the job that had been Flinck's alone. Rembrandt was just one of them.

In the event, the painting Rembrandt made was rejected. It was hung for a while, then rolled up and returned to him. It had been quite a large picture, as befitted a public building, so he cut it down and sold a bit of it to Stockholm where it now hangs, greatly reduced but much esteemed.

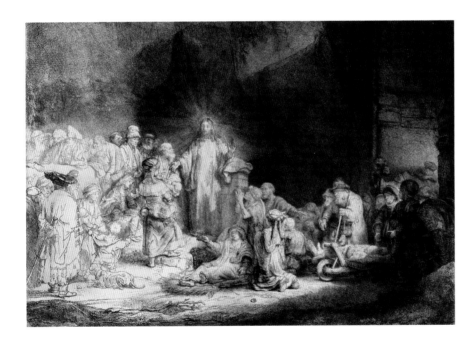

*Christ Preaching (**The Hundred Guilder Print**)*, c. 1643/9

Etching, drypoint and burin
Rembrandthuis, Amsterdam

Rembrandt was one of the great – if not the greatest – etchers of all time. And this is one of his greatest prints. It is known as *The Hundred Guilder Print* because that was the high price for which, so the story goes, Rembrandt himself bought it at an auction.

*Christ Preaching (**The Hundred Guilder Print**)*, c. 1643/9 (detail)

Etching, drypoint and burin
Rembrandthuis, Amsterdam

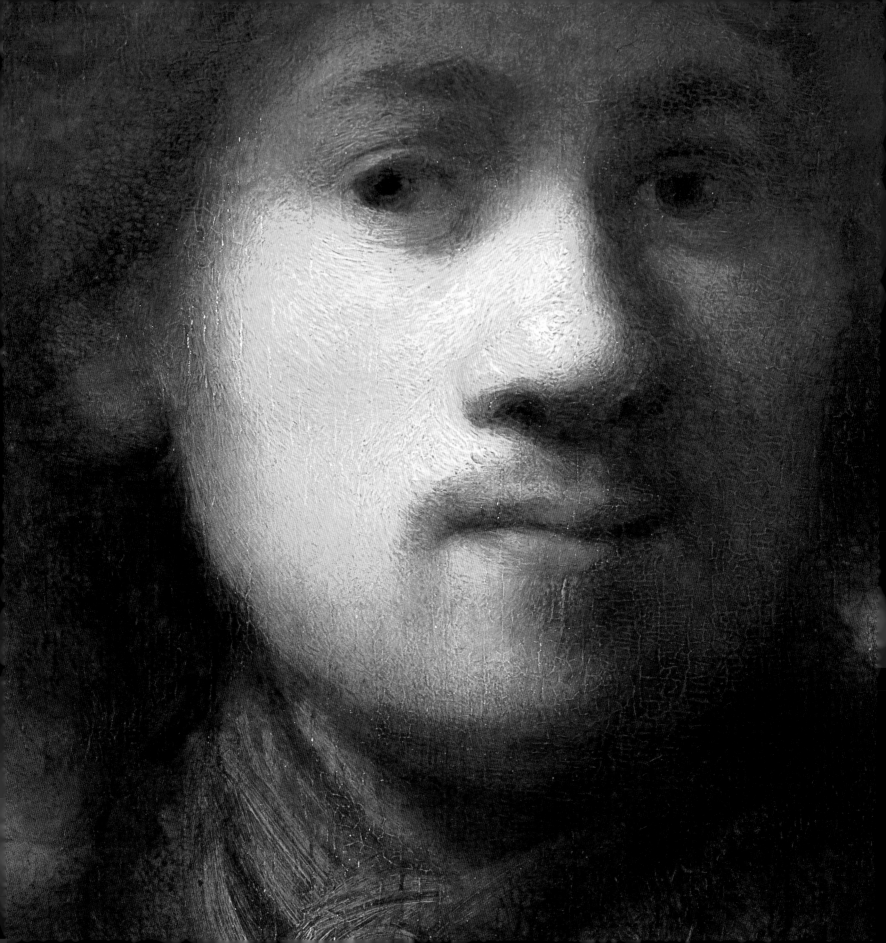

Rembrandt Research Project

One hundred years ago there were exactly 711 paintings accredited to Rembrandt van Rijn. They hung, proudly labelled as the work of an acknowledged genius, in great galleries and private collections the world over.

Now, four hundred years after his birth, that number has been trimmed to just over 300 – which means that there are more than a few disgruntled art lovers and gallery directors who are not convinced that the masterpiece in their collection is truly by a lesser man. All of which begs the question: when is a Rembrandt not a Rembrandt? The answer might seem simple. It is not. It is highly complex.

So much so that, in the wake of an enormous art scandal involving a number of fakes purporting to be by the Dutch artist Vermeer, in 1968 The Rembrandt Research Project was set up to sort the matter out once and for all: a six-man committee of Holland's greatest art experts. A stated aim of the Project was 'to cleanse the name of Rembrandt of pictures which were not by him and disfigure his image as a painter.' Easier said than done.

The way studios were organised in the seventeenth century does not make the experts' job exactly simple. Or free from controversy. A painting might have been made in Rembrandt's workshop, but not necessarily by his hand. It might have been copied by a student or finished by an assistant or made by another artist in the same studio. The master may have painted all of it or half of it or a bit of it or none of it – and still it might bear his signature, so long as he approved it. But which? Therein lies the rub.

To date the Rembrandt Research Project has published three weighty volumes of deliberations which have set a fair few cats among a fair few pigeons. More are yet to come. The present Director of the Project is the eminent Dutch art historian, Prof. Ernst van de Wetering. He is more than a Rembrandt expert. He is a Rembrandt enthusiast and art lover in the traditional sense of the term.

He first came into contact with the Rembrandt Research Project soon after it was formed and has been with Rembrandt ever since – so long, in fact, that he is probably the only person in the world to have seen every painting attributed to Rembrandt. One French newspaper has described him as 'the terror of certain conservators.'

'Attribution,' he says, 'is not an exact science. Science can prove a painting was from Rembrandt's studio, but not from his hand'.

Techniques have progressed so far that it is possible to identify just about everything else. There are x-rays and infra-red tests and chemical analyses and all sorts of other technical means of making a painting reveal its secrets. It is now known, for example, that *The Prophetess Hannah Reading* was painted on wood hewn from the same tree as *Hannah and Simeon in the Temple*, which in itself is impressive but does not mean, necessarily, that they are both by Rembrandt. They might have been painted on the same sort of timber, with the same sort of paint and with the same sort of brush, in the

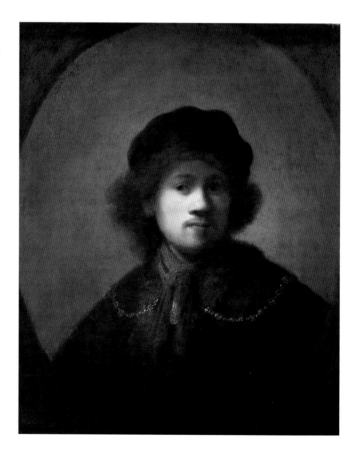

***Self-portrait with a Gold Chain,
c. 1630***
————————

Oil on panel
Walker Art Gallery, Liverpool

A portrait of Rembrandt, attributed to Rembrandt for hundreds of years, now, in

2005, disputed by the Rembrandt Research Project. Possibly by Jouderville they say – a verdict not accepted by the experts at the Liverpool gallery where it has hung for nearly fifty years and who resolutely continue to label it a Rembrandt.

same year and the same place, but that does not mean they were not done by two different men sitting next to each other and dipping their brushes into one pot.

One of the most challenging of recent debates is the portrait of Rembrandt in the Walker Art Gallery in Liverpool. It comes from the collection of Charles I. It would seem that in 1629 the English nobleman, Sir Robert Kerr, later to become Lord Ancrum, returned to England from a visit to the Dutch capital with several paintings which he had either bought or, more likely, had been given by Prince Frederick Hendrick. Sir Robert, in turn, gave them to King Charles and an inventory of the King's pictures made in 1640 lists: 'Item, above my Lo: [Lord] Ancrom's door the picture done by Rembrandt being his owne picture done by himself in a black capp and furred habit with a little goulden chain upon both his shoulders. In an oval and square black frame 28 x 23 in. Given to the Kinge by my Lo: [Lord] Ancrom.'

This description fits the Liverpool picture so exactly that the Walker Art Gallery experts believe there can be no doubt it is one of the paintings acquired by Sir Robert. The provenance of the inventory, hundreds of years old, made nine years before King Charles was beheaded by English revolutionaries, is not in doubt. It is preserved to this day in the Bodleian Library in Oxford. Just one problem. 'The painting is not by Rembrandt,' says Prof. van de Wetering. 'It is by somebody from his workshop'.

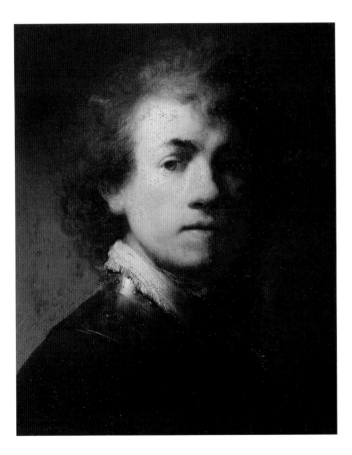

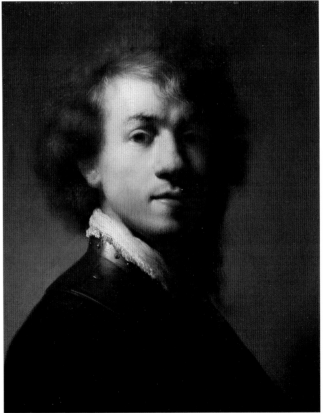

Self-portrait in a Gorget, c. 1629

Oil on panel
Germanisches Nationalmuseum,
Nuremberg

Two portraits that might look, to the unschooled eye, as if they were made by the same hand.

Both originally labelled as by Rembrandt. Now the one in the Mauritshuis (right) has been de-attributed by the Rembrandt Research Project. It is believed to be a copy of the painting in Nuremberg.

Anonymous after Rembrandt,
Self-portrait in a Gorget, c. 1629

Oil on panel
Royal Cabinet of Paintings Mauritshuis,
The Hague

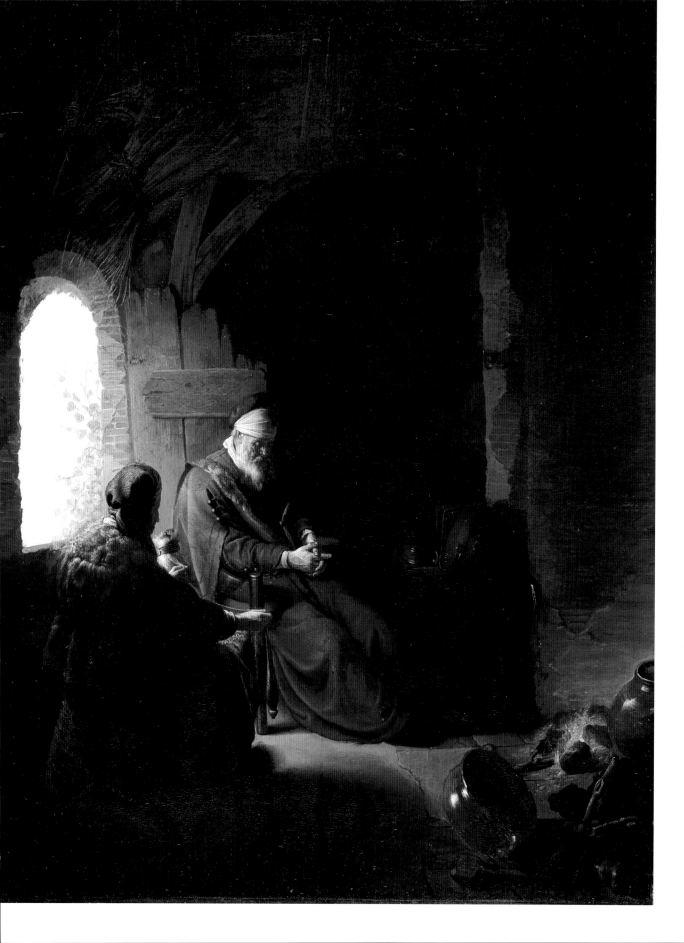

Anna and the Blind Tobit, c. 1630

Oil on panel
National Gallery, London

The Rembrandt Research Project has de-attributed this picture. For some time it was thought it might be by Gerrit Dou, Rembrandt's first pupil in Leiden, but the Dou experts rejected it. And the label in the National Gallery still proclaims the work to be by Rembrandt, just as the Walker Art Gallery do with their disputed self-portrait.
←

Portrait of Margaretha de Geer, 1661

Oil on canvas
National Gallery, London

On this occasion it was the Rembrandt Research Project that firmly believed the painting to be the work of Rembrandt while the National Gallery in London, the owner of the picture, for a long time remained unconvinced. Only in the late spring of 2005 did they change the label 'attributed to...' in the Gallery. It is now identified as a Rembrandt.
→

S

Six

Rembrandt drew this straight onto the etching plate, so the story goes, in the time it took for Jan Six's footman to run to Amsterdam and back to fetch a pot of mustard.

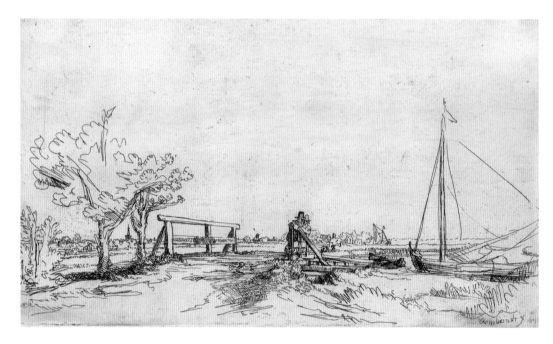

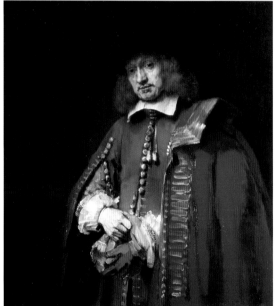

There's a story, probably apocryphal but often told, about Rembrandt's etching of a small footbridge on the country estate of his friend, the gentleman poet Jan Six. They say that Rembrandt wanted to show just how quickly he could make an etching, so he wagered his companions that he would complete the plate in the time it took for Jan Six's footman to run into Amsterdam, buy a pot of mustard and run back with it. He won his bet. Or so the story goes. But what is almost more interesting about this anecdote than the revelation that Rembrandt could dash off a fine etching in a matter of hours, is the reference to the artist and the intellectual as friends.

So far as it is possible to tell from a distance of four hundred years and a collection of dry old documents, Rembrandt was not greatly given to making friends of his clients. There were patrons, who usually came from the higher echelons of society. And there were friends. It was rare for one man to be both.

When he was looking for company Rembrandt chose easy companionship, rather than the stimulus of an intellectual mind or the challenge of a society grandee. The French critic, Roger de Piles (briefly imprisoned as a secret agent of Louis XIV), tells how a group of the artist's acquaintances wanted to know why he preferred the company of what they called the lower classes to Amsterdam's elite. Rembrandt did not deny it; he merely replied: 'When I want to relax, I don't go looking for honour but for freedom.'

Jan Six was one of the few. A patron, a client, an intellectual – and a friend. He was just 23 when Rembrandt, 12 years older, painted a portrait of the young man's widowed mother. The friendship seems to have begun around that

Portrait of Jan Six, 1647

Etching, drypoint and burin
Rembrandthuis, Amsterdam

Rembrandt's friend and patron in
Byronic pose, looking every inch the
poet and intellectual.

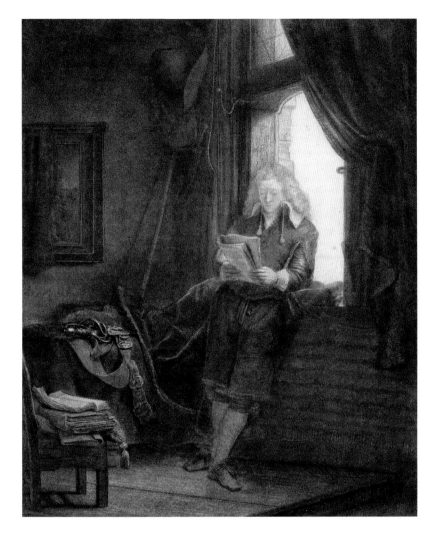

**Medea at the Wedding of Jason
and Creusa, 1648**

Etching and drypoint
Rembrandthuis, Amsterdam

The etching that Rembrandt
made for the first edition of Jan
Six's play Medea.

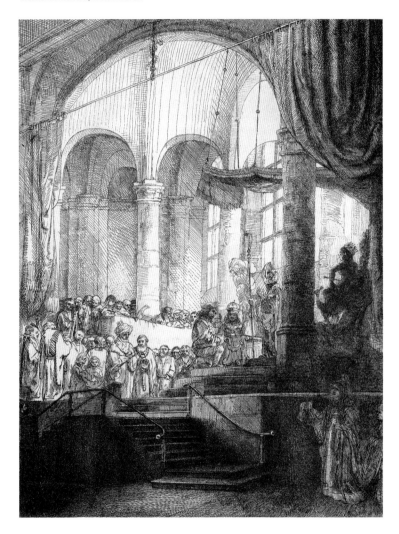

time. In 1647, came the first portrait – an etching for which
Rembrandt took considerable pains, making at least two
preliminary drawings; this, in itself, was unusual;
Rembrandt was much more given to virtuoso renderings
with speed and immediacy.

Soon after the etching of Six, an order for a portrait from
a new client was accompanied by the instruction, '(...) the

forenamed van Rijn shall etch from the life, to be of the
quality of the portrait of Heer van Six.' (The price he quoted
for this new portrait etching was 400 guilders; not cheap.)

If a client was well connected and his taste esteemed (and
Jan Six was both and more) his patronage could take a
painter far. Wheels within wheels. Jan Six was to marry the
daughter of Dr. Nicholaes Tulp, the eminent surgeon and

115

star of his own anatomy lesson. Captain Frans Banning-Cocq, leader of *The Night Watch*, was the brother-in-law of Andries de Graeff, who made a fuss when it came to paying for his portrait.

There were also the religious leaders, notably Johannes Wtenbogaert, returned from exile, whose portrait by Rembrandt was a *tour de force*. Before he had fled to France, Wtenbogaert had been a tutor to Frederick Hendrick, who was the cream of all Dutch patrons. Quite apart from his influence in his own country, his son William II of Orange married Mary Stuart, daughter of Charles I of England, who was at that time still in possession of his head.

Six was the ideal patron. He bought major works by Rembrandt and commissioned etchings. Then in 1654 came a life size, three-quarter length portrait of the writer looking Byronic – a portrait that for its insight and character is rated among Rembrandt's finest.

During the worst of Rembrandt's financial problems, it was to be Jan Six who came to the rescue with a loan of 1000 guilders, quite free of interest. It was not enough to save Rembrandt, of course, and when the time came to repay the money, Rembrandt could not meet the debt. Six was not a man to concern himself with such triviality: he sold the loan at a discount to a financier who went to law to get it back.

Whether it was this that caused embarrassment between the friends, or because Rembrandt required his sitters to give him rather more of their time than other portrait painters, or because he was expensive and had reputedly a difficult nature, or because he was not given to flattery or even, not to put too fine a point on it, kindness; whatever the reason, when the time came for a portrait of his bride, Jan Six went to Rembrandt's erstwhile assistant, now a frequent competitor for commissions, Govert Flinck.

He was not the first to do so. Nor the last.

These are two preparatory drawings for the etching on the previous page. They are in mirror image when compared with the print: etchings come out with everything reversed. The little dog in the first, rough study has been removed in the second drawing, which was used to make the print.

Study for the Portrait of Jan Six, 1647

Drawing in pen
Six Foundation, Amsterdam

Study for the Portrait of Jan Six, 1647

Drawing in chalk
Six Foundation, Amsterdam

Portrait of Johannes Wtenbogaert, 1633

Oil on canvas
Rijksmuseum, Amsterdam
→

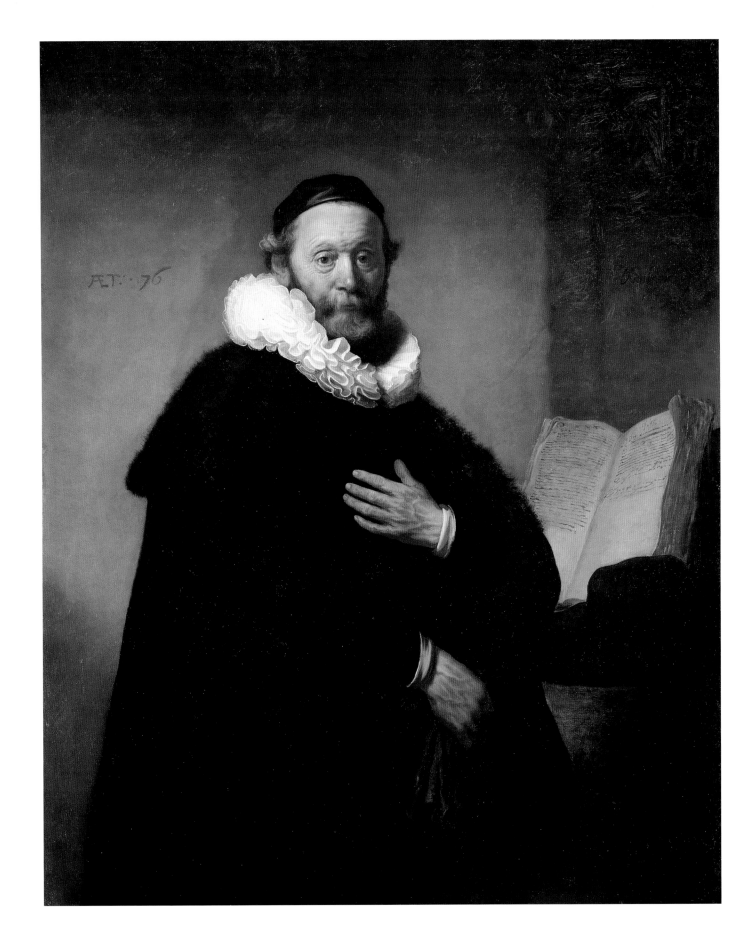

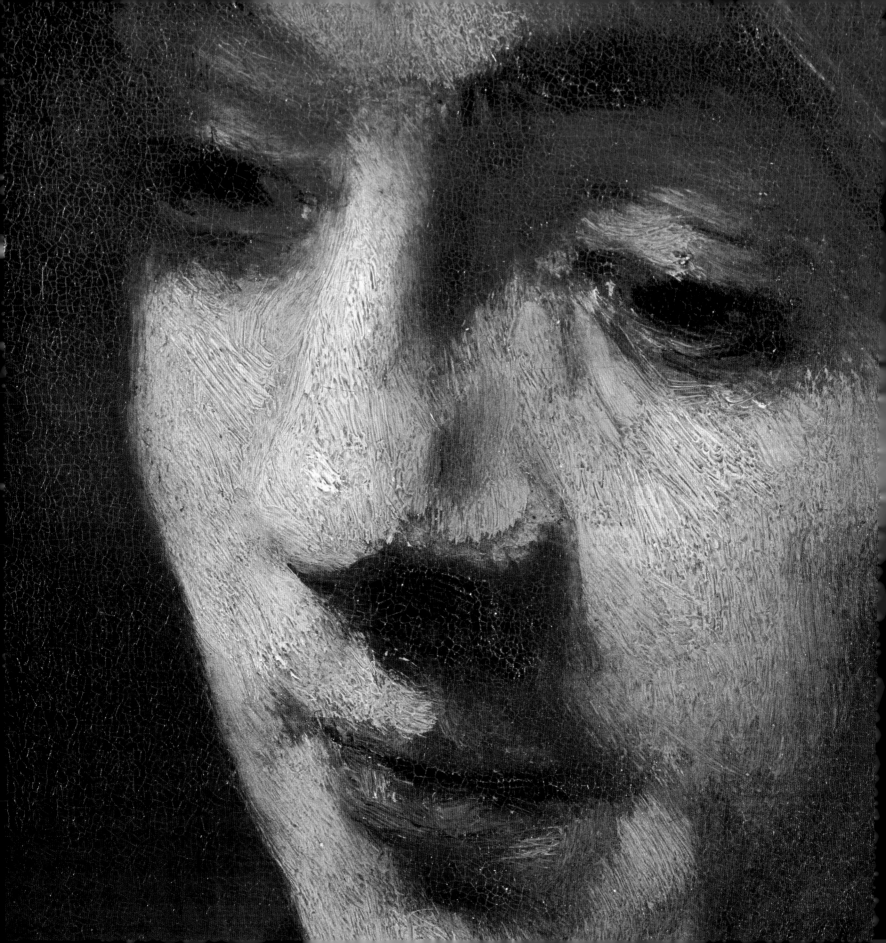

T
Titus

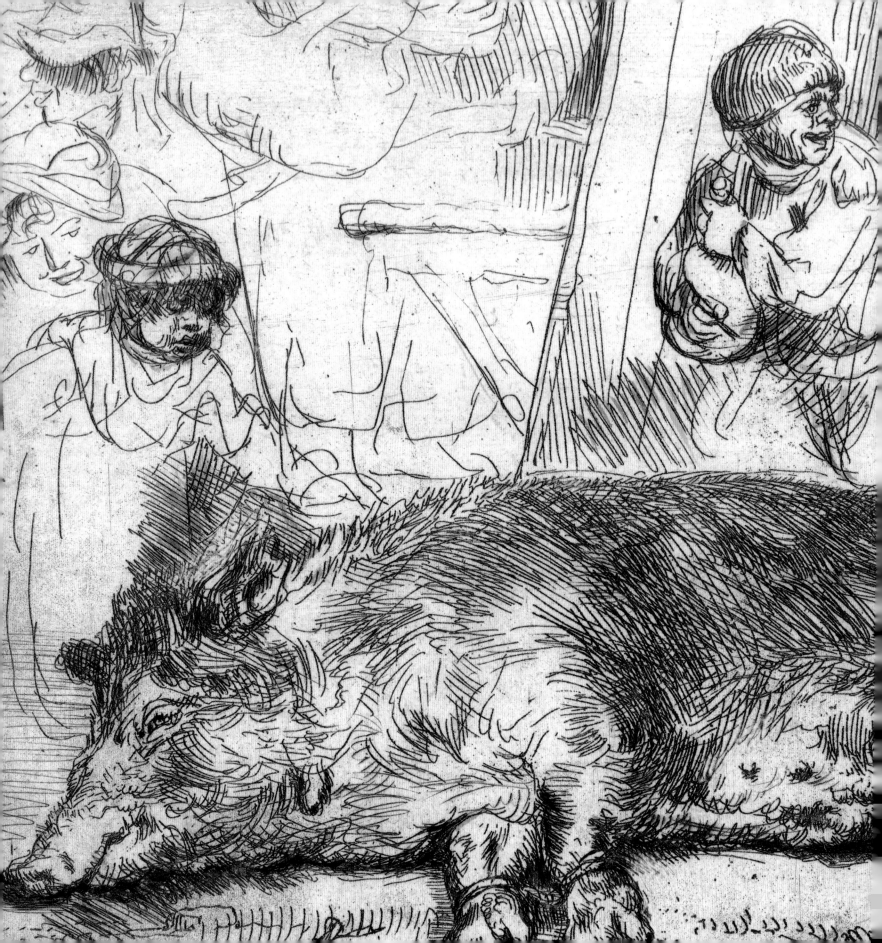

Titus van Rijn was the only child of Rembrandt and Saskia to live more than a few months. Even he died before his father. There was a time when it seemed as if he, too, might become an artist, but although there are pictures of him as a boy at his desk drawing and works by him in an inventory of his father's estate, nothing seems to have come of it. He was a fine looking young man with a sweet face, a slim body and a shock of curly auburn hair. Judging by the few records that have survived down the centuries, he was a loving, loyal son to an ageing father. And a proud one.

While visiting a publisher who wanted some engravings done for a book, Titus tried to persuade the man that Rembrandt should do the job. He was loud in Rembrandt's praise: 'My father can engrave with the best of them.' The publisher showed Titus work of the quality he wanted. Titus laughed. 'That's not so great,' he said. 'My father will do much better.'

Some years before, at the very height of his financial troubles, Rembrandt helped the 14 year old Titus 'reflecting on the frailty of human life, and the fact that nothing is more certain than death and less certain than its hour and manner, thought it would be well to make disposition of his worldly goods (...)' to make a will. He left everything to Rembrandt. The relatives on his mother's side were specifically excluded.

It had been nine years since the Uylenburghs had demanded a full account from Rembrandt of Saskia's estate, something they were fully entitled to do given the terms of her father's will and their belief in Rembrandt's profligacy.

121

A small boy is seen playing – and wearing popular headgear of the day for children just learning to walk, known as a *falling hat*. Titus would have been about a year old when his father made this etching.

The signature of 16-years old Titus Rembrandtszoon van Rijn, penned at the bottom of his (second) last will and testament on October 20, 1657

They had wanted to know the exact value of the couple's joint possessions on the day of her death. It took Rembrandt two months to complete and the total he came up with was 40,750 guilders.

Now, in 1657, it would seem that Rembrandt was making sure that, even if the Uylenburghs knew the worth of Titus' legacy, they would never get their hands on it. It was not until December 1660 that Rembrandt's insolvency was cleared and on the very same day he took Hendrickje and Titus to visit a notary, there to form themselves into a small company. Titus was now 19. His partnership with the woman who had once been his nurse and was now his father's common-law wife was set up to deal in art works – 'paintings, graphic arts, engravings and wood cuts as well as prints and curiosities'. Their advisor was to be none other than Rembrandt van Rijn. 'No-one is more suited to this purpose (...) they are both very much in need of aid and assistance in this enterprise.' In exchange, he would live with them free of charge. They would give him his meals and lend him money for his materials and in return they might sell his pictures. The arrangement seems to have worked well.

On June 19, 1663, when he was 21 years old, Titus was granted his legal majority. At last he was allowed to take possession of his mother's estate; or what remained of it. It was, by all accounts, some 13,000 guilders less than it should have been.

Ironically, what was left returned eventually to the Uylenburgh clan. Some two and a half years after he inherited his money, Titus married. The bride's name was Magdalena van Loo and they were related by lawsuit. Saskia's elder sister, Hiskia, was an Uylenburgh by birth and a van Loo by marriage; it was in her house that Saskia and Rembrandt had their wedding feast. Titus' new wife, Magdalena, was Hiskia's niece. Back in the bad old days, in 1656, Hiskia was among those who sued his father for money. Now, everything that Titus had would come to his bride with their marriage.

The promise of a bright new future for the happy couple was never to be realised. They had only eight months in which to enjoy married life. On September 7, 1668, Titus, the last of Saskia's children, the comfort of his father's old age, died of the plague. Just over a year later his wife followed him, leaving yet another van Rijn orphan, their baby daughter Titia. She had never known her father. She had been born seven months after his death and now she had lost her mother. She was not even a year old – just about the same age, in fact, as was her father when he had lost his mother, Saskia.

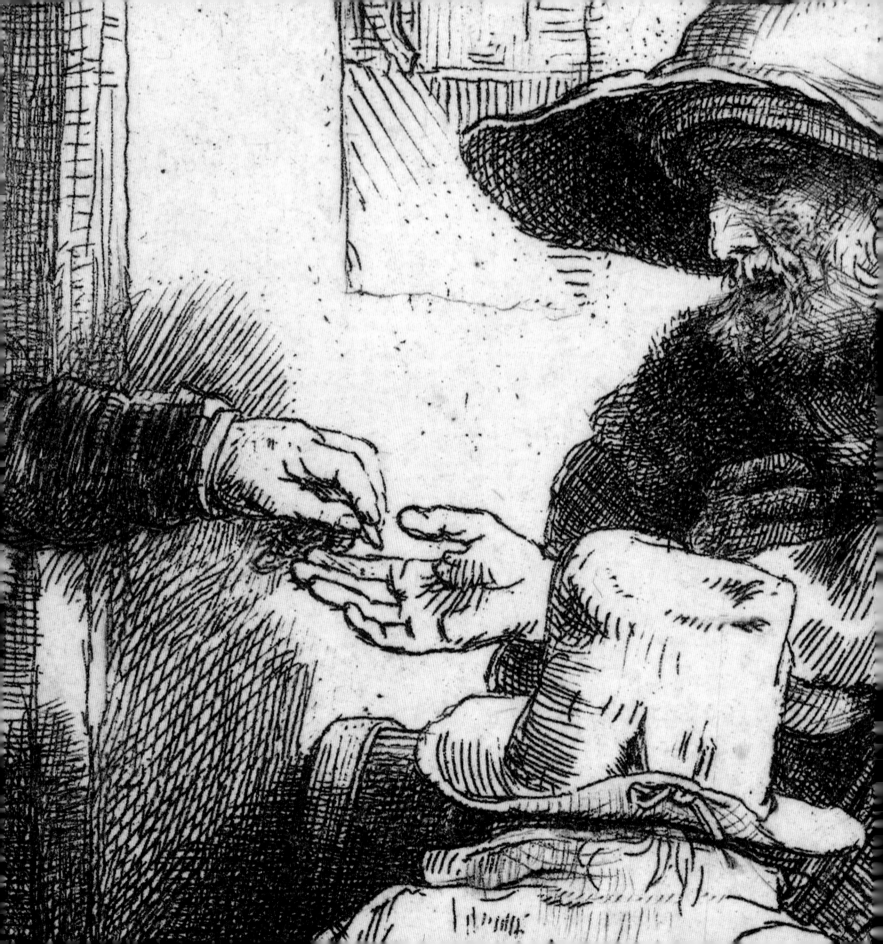

Uomo
Famoso

Self-portrait, 1669

Oil on canvas
Uffizi Gallery,
Florence

This self-portrait is
believed to be the
one that Cosimo
de'Medici bought
when he went to
Amsterdam for the
second time. It was
painted in the year
Rembrandt died.

Beggars Receiving Alms at the Door of a House, 1648

Etching, drypoint and burin
Rembrandthuis, Amsterdam

Six days before Christmas, 1667, a small procession of coaches carrying the Grand Duke of Tuscany, Cosimo de'Medici, and his retinue arrived in Amsterdam. The visit was supposed to be incognito but Cosimo had brought so many courtiers and was so lavish with his tips that news of their arrival quickly spread through the breadth of the city.

Cosimo was 25 years old, a young nobleman of wealth and privilege whose youthful adventures were recorded in his travel journal. He was on a Grand Tour of Europe, the cultural journey that in those days was an expected part of the education of any young gentleman who pretended to the title.

Everywhere he went it was understood that Cosimo should be exposed to all that was fine and good in contemporary art, and in the Netherlands alone the Duke and his companions visited the studios of fifteen artists. To some he paid the honour of a visit, others had to call on him.

Amsterdam was a fine place to be in 1667. There was peace with England at last. Culture, learning and trade flourished. The sights and sounds of prosperity were everywhere; bells ringing, singers singing, actors declaiming, the streets loud with the cries of market traders and the tongues of many nations.

It was a cold winter that year. The canals were deep frozen and the ice sang to the cut and swirl of the skaters. One Thursday morning, four days after Christmas, Cosimo and his entourage set off in their elegant clothes, scrunching their way through the mud of the Rozengracht against the press of wandering musicians and scrofulous beggars, and all the while trailed by a posse of urchins and dogs and Amsterdamers jostling for a view of the Italians.

Rembrandt had been living here for nine years now, in a house somewhat more modest than the fine home on the Breestraat with its high ceilinged entrance hall hung heavy with the works of the great artists of the day. It stood opposite an amusement park in a spirited area of outdoor markets and artisans' homes and, for a rent of 225 guilders a year, it gave them space enough for the depleted family. There was a studio in which Rembrandt could work, and room for the *kunstkamer* of plaster heads and hats and helmets and goodness knows what else which he had somehow managed to accumulate all over again.

Cosimo's journal told it all. At Rembrandt's studio they had no finished works for sale so the Duke had to take his purse and his entourage and go off to find someone, somewhere, who did.

It is not recorded where or when the young de'Medici found the picture he wanted and took back to Italy, only that 'his highness was received most cordially.'

When the Italians came to write of the artists the Duke had seen, Rembrandt van Rijn was mentioned quite specifically. They called him an 'uomo famoso'. A 'pittore famoso'. A famous man. A famous painter. All of which more than puts paid to the romantic myth that Rembrandt died in obscurity.

There is nothing in Cosimo's journal, nor indeed in the

fact of his visit, that remotely suggests that Rembrandt's status had diminished over the years. And yet, there exists today a popular legend which insists on relegating him to a kind of artistic limbo, the victim of fickle fancy who lived out his later years unloved and unsung and who died forgotten, alone and in poverty. The truth is very different: Rembrandt remained a celebrated man until his dying day.

Only three years before Cosimo's visit, a learned German clergyman and art lover not only named the 58-year-old Dutchman in his published record of 'The Names of the Most Distinguished European Painters', he called Rembrandt 'The Miracle of Our Age.' The list of 166 names included painters such as Leonardo da Vinci, Titian and Rubens. But Rembrandt van Rijn was the one and only to be given such an accolade.

Typical of the sort of scene from Amsterdam life that caused offence to some of the more prudish of Rembrandt's critics.

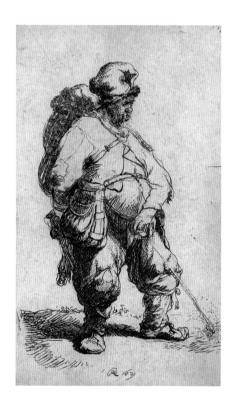

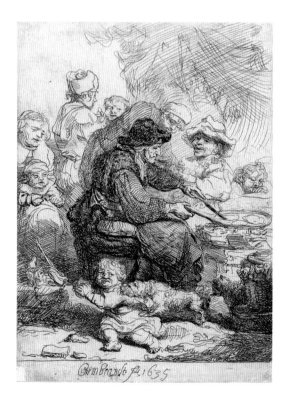

A Man Making Water, 1631

Etching
Rembrandthuis, Amsterdam
↑

The Pancake Woman, 1635

Etching
Rembrandthuis, Amsterdam
↗

The Skater, c. 1639

Etching and drypoint
Rembrandthuis, Amsterdam
→

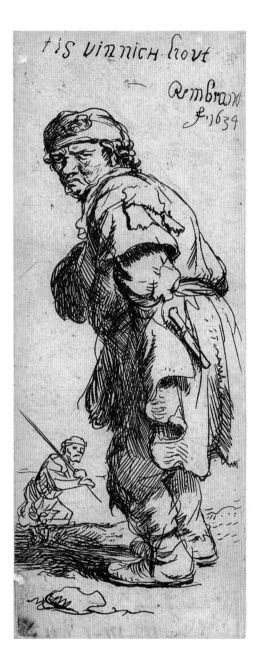

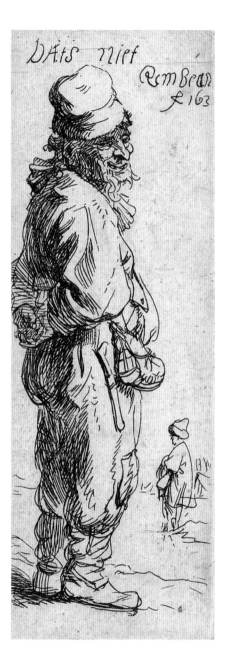

Beggar Seated, Warming his Hands
at a Brazier, c. 1630
——————

Etching
Rembrandthuis, Amsterdam

A Peasant calling out 'It's damned cold' and
another replying 'It's not', 1634
——————

Etchings
Rembrandthuis, Amsterdam

↑↗

Varnish

A little known fact about Rembrandt's painting *The Night Watch*, is that it is, in truth, no such thing. By the time it acquired its name, sometime in the eighteenth century, it had hung for years beside peat burning fires in the smoky halls of the civic guard. Time and pollution had combined to darken the varnish to such an extent that day had become night.

Two hundred or so years later, it was decided to clean and re-varnish the monumental work. At which point it dawned on the conservators that, if it were to be called a Watch of any kind, it should be more correctly called The Day Watch. Somehow, though, that name doesn't have quite the same ring to it, which is probably why it never caught on. Purists are inclined to call it 'The Company of Captain Frans Banning-Cocq Prepares to Move Out' – hardly a catchy title and not one that trips lightly off the tongue. And so, *The Night Watch* it remains.

Varnish might be the great protector against the vicissitudes of time and the madness of vandals. It might illuminate brushwork and colour. But, left too long, it can change the whole perception of a painting. Dirty varnish has been responsible for more than a few misconceptions about the works of Rembrandt, as Manja Zeldenrust, Head

Conservator at the Rijksmuseum in Amsterdam, knows all too well. 'When a painting is getting old, much like a person it needs tender, loving care. The layers of paint may begin to crack and the colours may drop. Worse, the varnish which was first put on not only to bring out the texture of the artist's brush work, but to protect the picture, may yellow, thicken and crack,' she says. 'That's why a picture needs careful cleaning, although the whole art of restoration is to learn to do less and less. Sometimes the best thing for a painting is to do nothing at all.

'Then again, removing layers of old varnish is like taking off your sunglasses.'

Manja Zeldenrust has been looking after Rembrandt works (among others in the Rijksmuseum collection) nearly all her working life. She was a junior intern during the repairs to *The Night Watch* after someone slashed it with a knife. One of her jobs, when the team went to lunch, was to open the curtains that covered the large window of the room in which the restorers worked. This daily unveiling turned out to be the surprise attraction of the season at the Rijksmuseum, despite the fact that half the time all that could be seen was the back of the painting lying face down on the floor.

The Syndics of the Drapers Guild, 1662
———
Oil on canvas
Rijksmuseum, Amsterdam

Jeremiah Lamenting the Destruction of Jerusalem, 1630 (detail)
———
Oil on panel
Rijksmuseum, Amsterdam

Close focus detail of Jeremiah's foot and the richly coloured carpet on which it rested showing the way the red glaze used by Rembrandt added lustre and what he called 'sparkle'.

→

Portrait of a Woman known as 'Maria Trip', 1639 **(detail)**

Oil on panel
Rijksmuseum, Amsterdam

When the time came to remove the varnish and retouch the paint layers, so great was the fascination for the work in progress that several of the attendants were offered bribes to tweak a corner of the curtains early, secretly, while the conservators were still up their ladders and the picture was in view. All, of course, resisted.

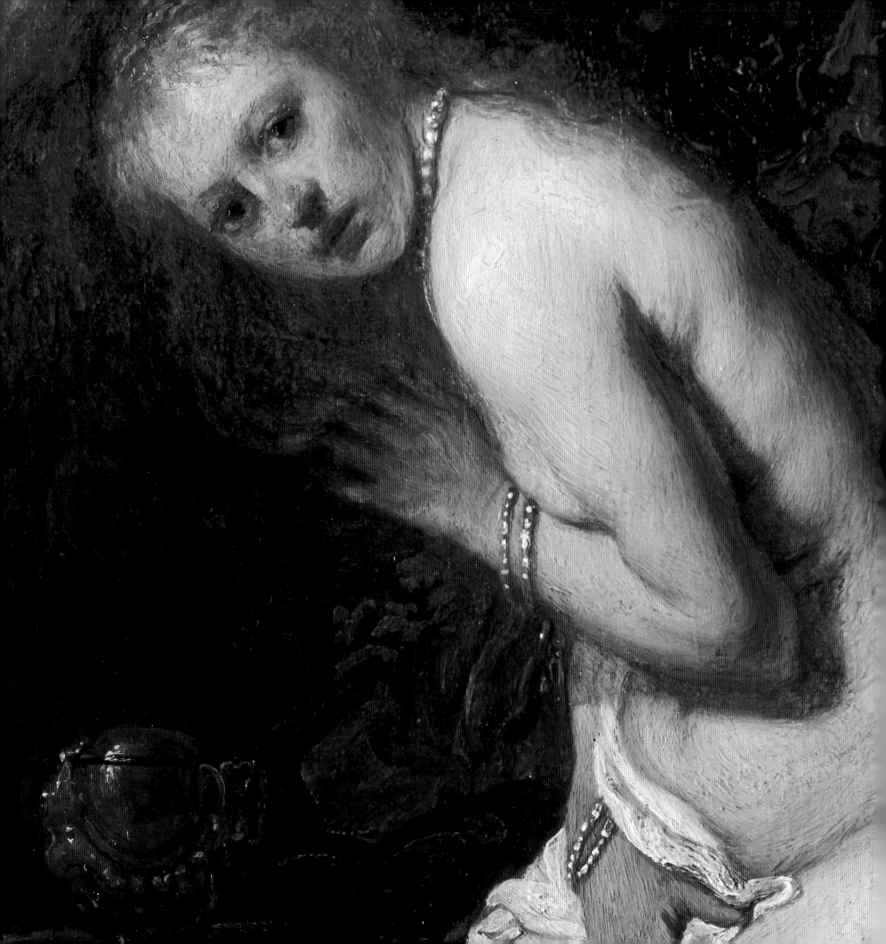

Women

At the time Rembrandt was working in Holland there was no word in the Dutch language for the nude. The best on offer was *naakt* which more accurately meant *nakedness* rather than the artistic portrayal of classic antiquity. And posing in the nude, whether there was a word for it or not, was certainly not an acceptable occupation in seventeenth century Amsterdam, no matter how eminent or respectable the artist. Govert Flinck, who had studied with Rembrandt in Uylenburgh's studio (and may well have taken over the master's role when he left) had three models who would pose for him without clothes. Two of them ran notorious whore-houses. A third was later to sue a man for matrimony and lost her case because she had been 'painted as naked as anyone could possibly be.'

All of which probably suited Rembrandt just fine. He constantly blurred the line between the classic nude and everyday woman. One was viewed as art, the other as vulgarity. And it was the so-called vulgar version Rembrandt chose to portray. He believed in painting women as he saw them. As they were. If his nude model had a spreading waistline and was carrying a bit of extra weight to the rear, then that was the way he painted her, etched her, drew her or whatever. As crumpled in art as she was in life.

And if she were not as young as she might have been and her stomach looked as if it could benefit from a good going over with a warm steam iron, then there she was, just as nature and life had made her. If she had cellulite and wrinkles and open pores and lumpy breasts and all the lesser attributes of real life woman, if her thighs had the strength of a dray horse and her legs bore the marks of the garters that held up her socks, then that's how she appeared in the frame and to hell with the critics.

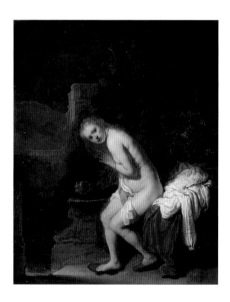

Susanna and the Elders, 1634
———
Oil on panel
Royal Cabinet of Paintings Mauritshuis,
The Hague

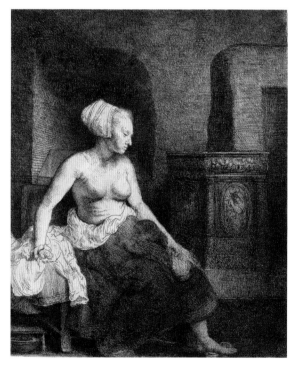

Woman Sitting Half-dressed beside a Stove, 1658
———
Etching, drypoint and burin
Rembrandthuis, Amsterdam

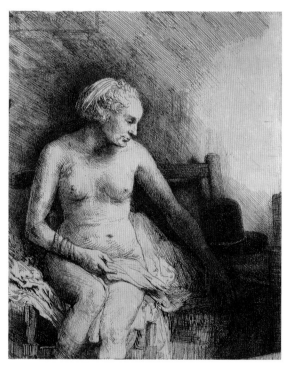

Woman at the Bath with a Hat beside her, 1658
———
Etching and drypoint
Rembrandthuis, Amsterdam

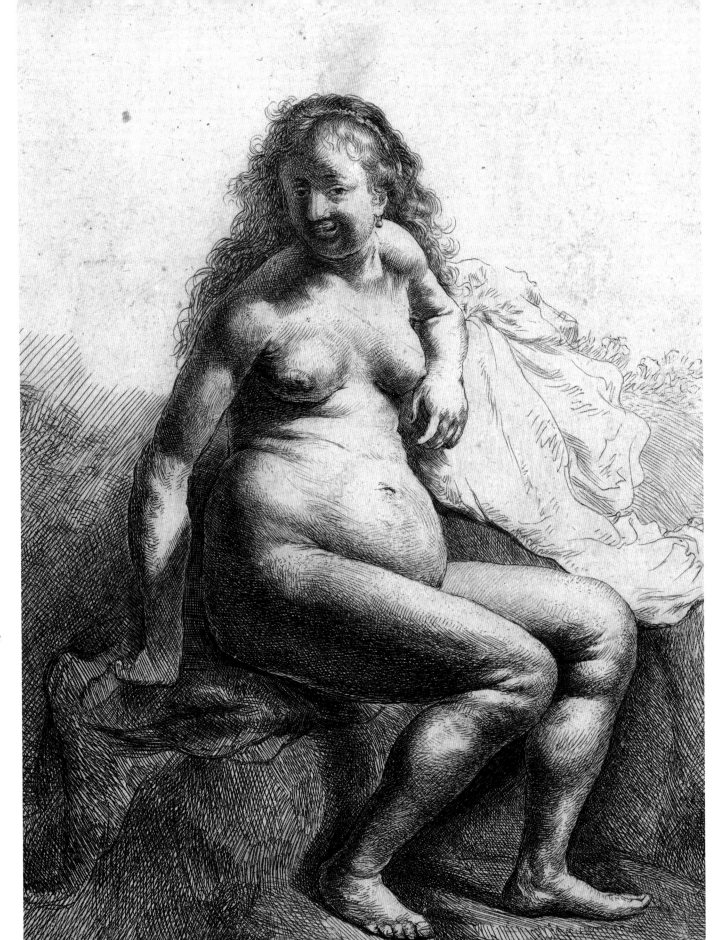

***Naked Woman Seated
on a Mound***, c. 1631

Etching
Rembrandthuis,
Amsterdam

The critics and the
purists hated the
fact that Rembrandt
drew reality – even
down to the garter
marks on this
woman's legs. Not
the stuff that classic
nudes are made of.

Naked Woman with an Arrow, 1661

Etching, drypoint and burin
Rembrandthuis, Amsterdam

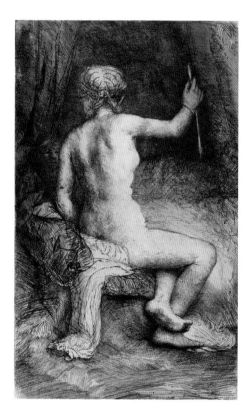

Naked Woman Bathing her Feet in a Brook, 1658

Etching
Rembrandthuis, Amsterdam

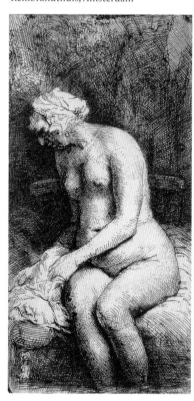

Diana Bathing, c. 1631

Etching
Rembrandthuis, Amsterdam

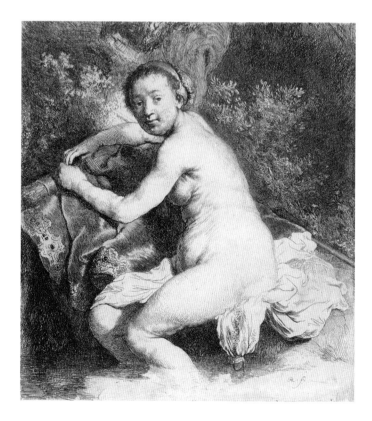

And critics there were in plenty. Even the virtuous Susanna (lusted after by the Elders) was described by one as a 'washerwoman' and the choleric Jan de Bisschop complained in 1671 that Rembrandt portrayed a woman 'with swollen belly and hanging breasts.' The first man to catalogue Rembrandt's prints thought he 'had no understanding of working with the nude (...) I don't believe there is a single one that can be cited that is not disagreeable to the eye.' And that from an admirer.

But the rudest of all his critics, the classicist Joachim von Sandrart, a one time apprentice to Rubens, attacked his nudes at the most basic level, complaining angrily that Rembrandt 'did not hesitate to oppose and contradict our rules of art, such as anatomy and the proportions of the human body, perspective and the usefulness of classical statues.' And Houbraken, as outspoken as ever, had to have his say: 'Usually the pictures make one sick and it is incredible that such an ingenious man should be so wilful in his choice'.

In those days a poem by a popular writer was considered something of a barometer of public taste, a sort of seventeenth century equivalent of a comment in a tabloid newspaper. It fell to Andries Pels, the Dutch dramatist, to complain in verse about Rembrandt's women:

The Fall of Man, 1638

Etching
Rembrandthuis, Amsterdam

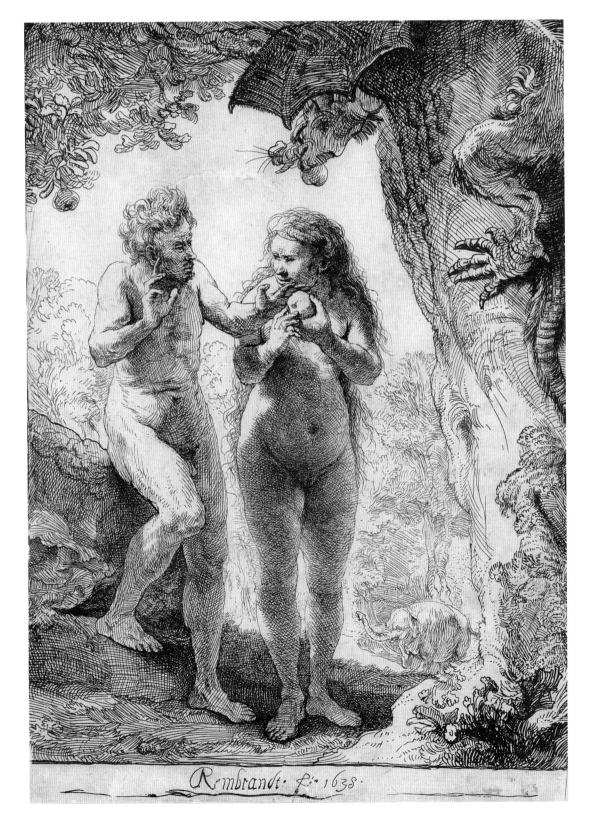

'(...) *flabby breasts,*
'*Ill-shaped hands, nay, the traces of the lacings*
'*Of the corsets on the stomach, and of the garters*
on the legs,
'*Must be visible, if nature was to get her due.*
'*This is* his Nature, *which would stand no rules*
'*No principles of proportion in the human body.'*

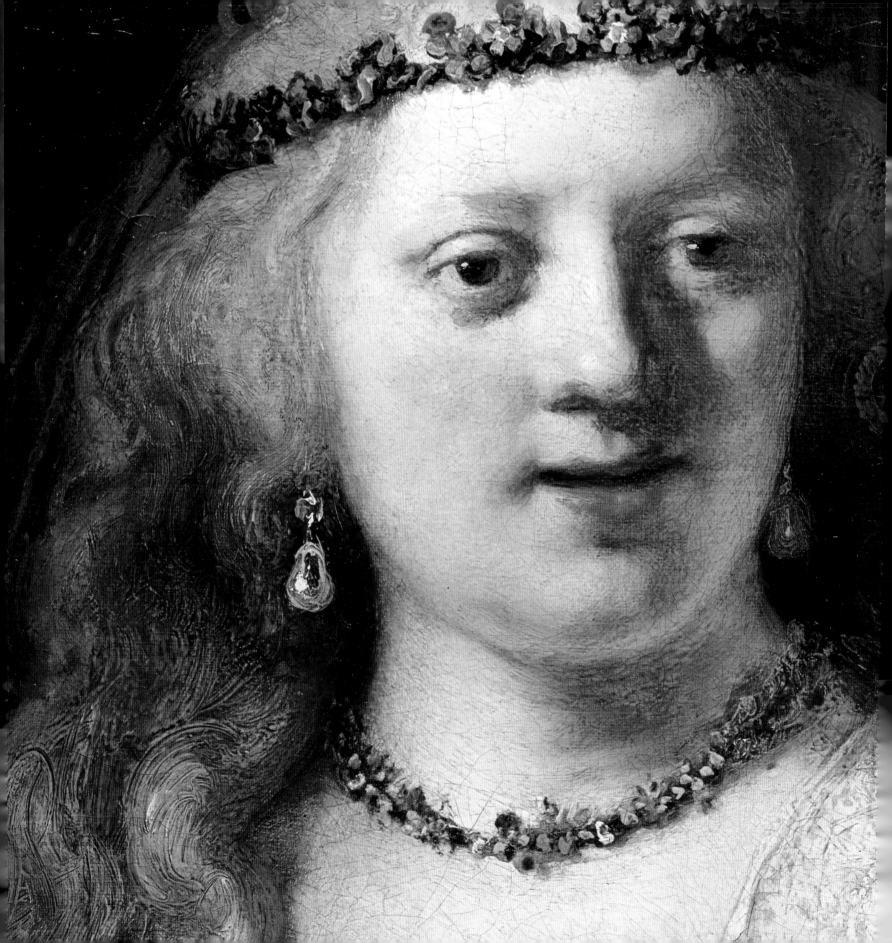

One of the x-rays, made at the National Gallery in London, revealing the gory origins of this tender picture.

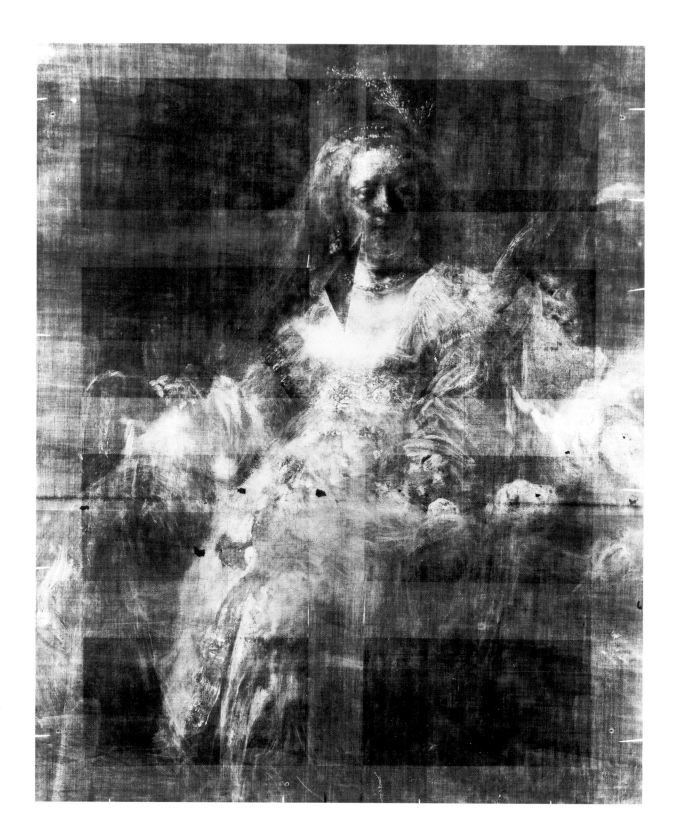

Oil on canvas
National Gallery, London

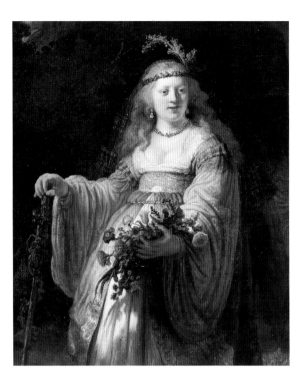

There is, in the National Gallery in London, an idyllic painting of a young woman decked out in the costume of a shepherdess. It is generally thought to be of Rembrandt's much loved wife, Saskia. Dated 1635, just one year after their marriage, it was painted by the young husband in the first flush of married life, when Saskia was still a bride.

But this picture of a pretty young woman holding a bunch of flowers hides a very different image. A darker image. An image of blood and gore and dreadful vengeance. Underneath this happy pastoral symphony, recently revealed by x-ray, is a Biblical tale of violent death and retribution. Saskia is not the Arcadian beauty of her lover's imagining but the Biblical heroine, Judith, fresh from chopping off the head of her sworn enemy.

Instead of a sweet smelling posy she holds, so far as anyone can tell, the severed head of her victim, the Assyrian general Holofernes. And the staff, prettily entwined with leaves, that Saskia has in her hand is thought to have been the gory sword that Judith used to do the dreadful deed.

What makes this reworking of a Biblical theme into a picture of bucolic bliss so astonishing, is the fact that Rembrandt, at the time newly enamoured of his young bride, barely changed anything from the original. The low cut bodice she sports matches the generous cleavage displayed by Judith in a striking painting of the Jewish warrior made by Rubens in 1616. Flora does have just the merest hint of a double chin but then, if later portraits are anything to go by, so did Saskia; no one can say whether Judith had one too.

Not even the expression on her face has been altered. 'Maybe he softened it a touch, to present Saskia in a rather more benign image,' says David Bomford, Senior Conservator at the National Gallery. 'But only a touch.'

The sole reason offered for this dramatic change is market pressure. No doubt a pleasing picture of a pretty woman would sell better than a gory Biblical scene. 'And Rembrandt was nothing if not pragmatic,' says David Bomford.

Unless he painted it to give his wife pleasure, of course. That is something an x-ray cannot reveal.

ij

The IJ

Immediately behind what is today Amsterdam's main railway station is a broad stretch of rough, grey water known as the IJ (pronounced *aye*). On the far side stand modern flats and small houses to which ferries ply with busy commuters and their bicycles. Four hundred years ago the beacon that welcomed the seafarer to seventeenth century Amsterdam, much as the Statue of Liberty greets the modern day visitor to New York, was a short line of gallows where swung the rotting corpses of Holland's malefactors.

It was here that a young Danish girl by the name of Elsje Christiaens met her end. She was 18 years old and a lodger in the boarding house of a woman to whom she owed two weeks rent. When the landlady threatened to take the young Dane's belongs in lieu of 'sleeping money' and set about her with a broomstick, Elsje retaliated. With an axe. She admitted the murder and her words – which may well have been extracted by torture – are recorded in the *Book of Confessions* preserved in the city archives.

She had been in Amsterdam for just two weeks and had taken rooms in the hostel run by the victim, expecting to find work in the city and to be able to pay for her bed. When the woman attacked her she 'lost control' and retaliated with an axe which just happened to be lying nearby. At the hearing the next day she was sentenced to be 'strangled' and hung on a pole until dead, then hit about the head by the hangman with the same axe.

After death, her body was taken from the wooden scaffold in front of Amsterdam Town Hall and carried to the gallows across the IJ where she was left 'to be devoured by the air and the birds.'

The story of the violent end to a young girl's life was the talk of Amsterdam. On the very day of the execution Rembrandt had himself rowed cross the IJ to the Field of Gallows where Elsje now hung. At her side dangled the axe as a visible object lesson to all incipient axe murderers. So taken was he with the sorry sight that Rembrandt returned with his students, all of whom made drawings of the little corpse hung out for the birds with her chopper.

View across the IJ seen from the Diemerdijk, c. 1650

Drawing in pen and brush
Duke of Devonshire, Chatsworth
Settlement
↑

View across the IJ towards Nieuwendam, c. 1650

Drawing in pen and brush
Museum Boijmans Van
Beuningen, Rotterdam
→

Woman on the Gallows, 1664

Drawing in pen and brush
Metropolitan Museum of Art,
New York

'To be devoured by the air and
the birds (...)' Elsje Christiaens
hangs from the gallows on the
banks of the IJ, her little axe at
her side.

↖

***View of Amsterdam across the IJ,
c. 1640***

Etching
Rembrandthuis, Amsterdam

↑

Anthony van Borssum,
***The Volewijck with the Galgeveld,
c. 1664***

Drawing and watercolour
Rijksmuseum, Amsterdam

↓

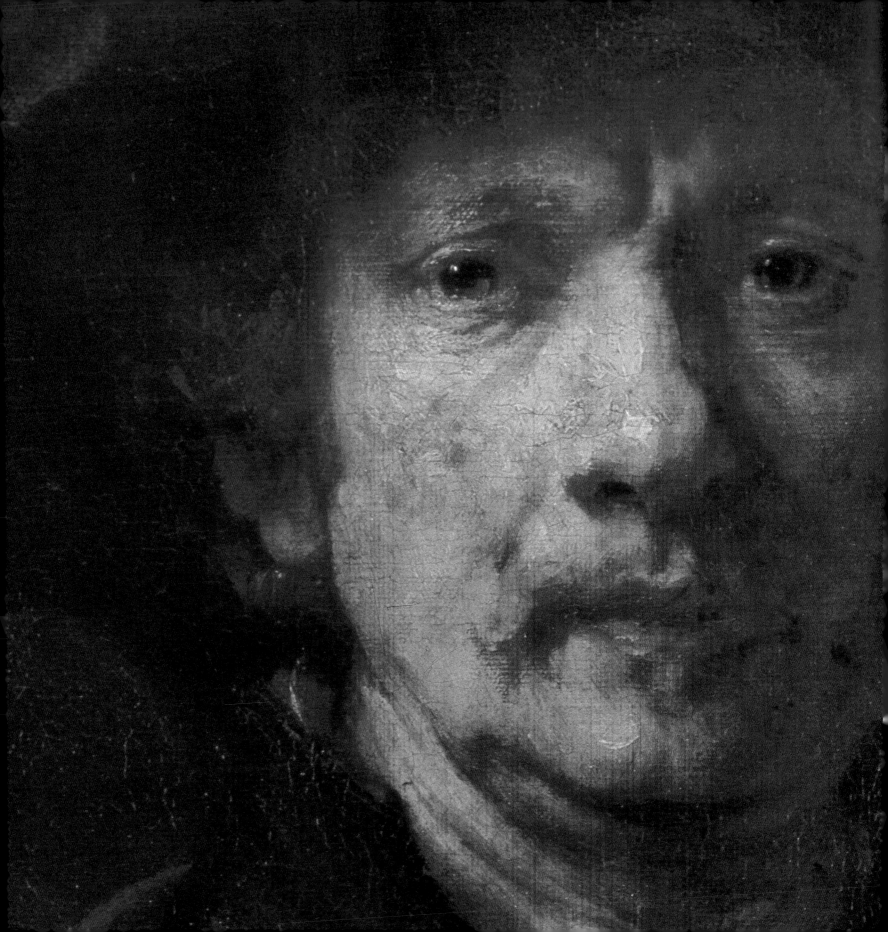

'Zelfportret'

There is, in all probability, no one else in the history of Western art who has painted his own image quite so often or quite so compulsively as Rembrandt van Rijn. Where others wrote their autobiographies, Rembrandt painted his. At the turn of the new millennium there were, accredited to his name, about 40 oils, 30 etchings and many drawings of the artist by himself: a total of 80 or so self-portraits.

Not that the modern Dutch name *zelfportret* was used in the seventeenth century. The term had yet to be coined. They were known as portraits of the artist by the artist. Or as one seventeenth century inventory put it: 'his owne picture and done by himself'.

Rembrandt's portraits of the artist *done by himself* illustrate his life so graphically that in 1956 a Dutch film maker collected together as many as he could lay his hands on and, by shooting them in chronological order, mixing infinitely slowly from one to the next, the eyes an ever constant feature, he achieved the effect of making the face age visibly over a period of forty or so years. By his own hand.

The skin noticeably thickened, the jowls sagged, the gleam in the eyes dimmed, the hair lost the fierce abundance of youth. All his own work. A kind of Dorian Grey in reverse. No doubt the great face maker himself would have been fascinated to see the effect achieved.

Early critics put Rembrandt's obsessive representation of the self down to some sort of navel gazing exercise, an indulgence of ego. Later commentators, with the benefit of hindsight, dismiss this theory. They believe his preoccupation was less an exploration of self, more an exploration of art.

Any suggestion that Rembrandt was a man of personal vanity holds no credence. If he were in any way interested in his own appearance it was to observe emotion and expression. Not whether he looked good. As an Italian historian (who used the familiar conduit of information, the erstwhile Rembrandt student) unkindly remarked: 'the ugly, plebeian face by which he was ill favoured, was accompanied by untidy and dirty clothes, since it was his custom, when working, to wipe his brushes on himself (...).' Not the actions of a vain man, rather the habits of one obsessed with his art.

The same biographer even goes on to say that Rembrandt would become so involved with what he was doing when he was working that 'he would not have granted an audience to the first monarch in the world, who would have had to return again and again until he found him no longer engaged on that work (...).' Exactly. A man immersed in his art. And yet another remarked that Rembrandt might sketch a face ten different ways before he painted it and could spend 'a day or even two placing a turban according to his taste.'

A man, then, so absorbed in art that, in June 1666, he offered 1000 guilders for a picture by Holbein – ignoring the fact that he was once again seriously in arrears with his rent.

Rembrandt van Rijn died on October 4, 1669, at the age of 63. No cause of death was recorded. Of his family, only Cornelia, his 15 year old daughter by Hendrickje, remained at his side. Her mother had gone, and Titus too, both victims of the black death which took 30,000 lives in the Province of Holland in one epidemic alone; and, years before, Rembrandt's young wife, Saskia, and all her babies save one.

Self-portrait **Drawing at a Window**, 1648 **(detail)**

Etching, drypoint and burin
Rembrandthuis, Amsterdam

Self-portrait, 1669

Oil on canvas
National Gallery, London

One of the last – if not *the* last self-portrait that Rembrandt painted. Made in the year of his death.
→

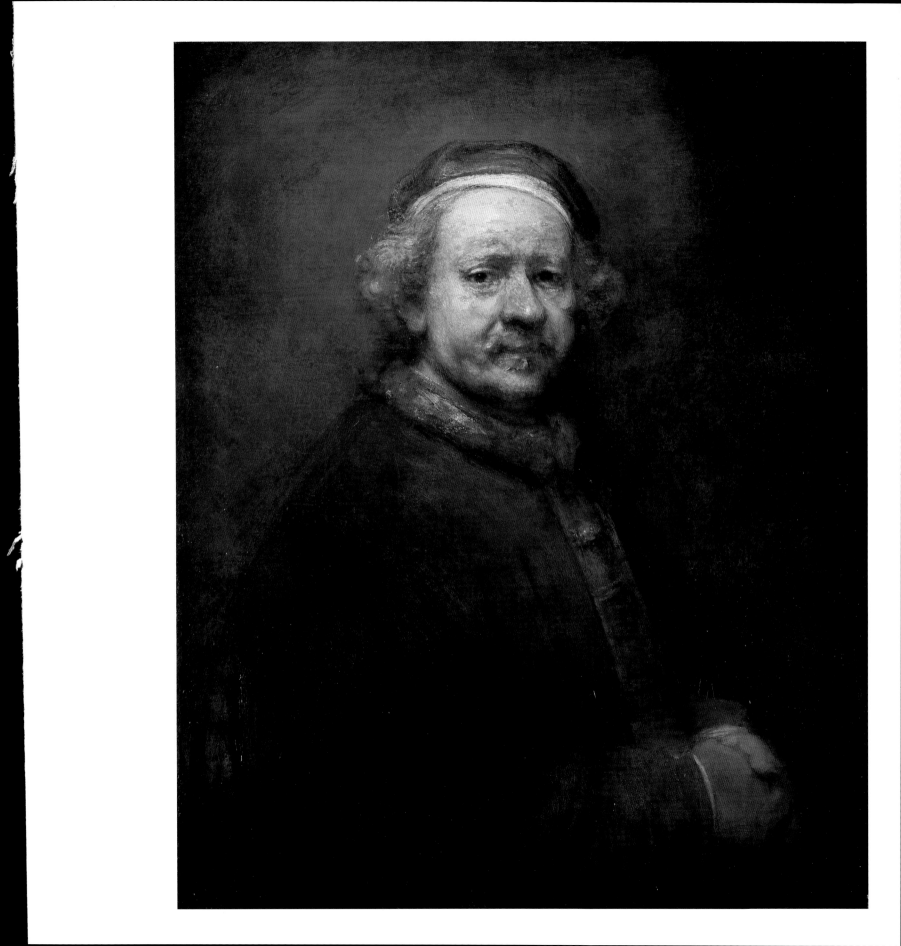

Self-portrait as St. Paul, 1661

Oil on canvas
Rijksmuseum, Amsterdam

One of the most enduring images
of all the 80 or so portraits that
Rembrandt made of himself.

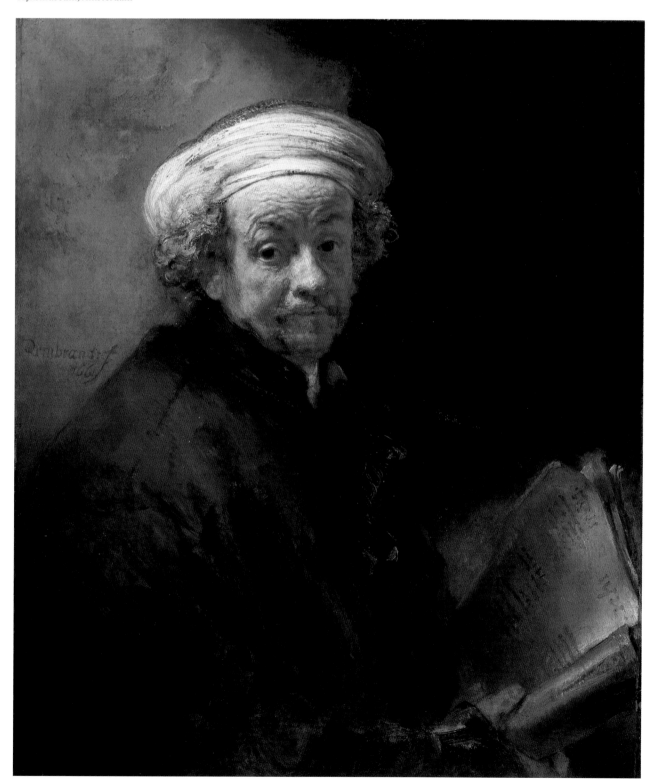

Self-portrait Drawing at a Window, 1648

Etching, drypoint and burin
Rembrandthuis, Amsterdam

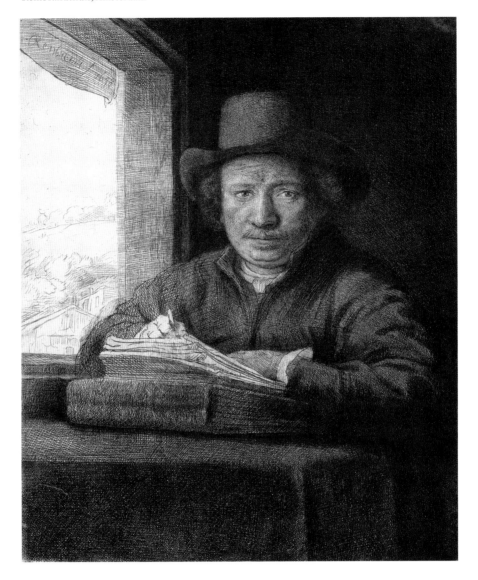

There were sixteen pallbearers at his burial in the Westerkerk. The funeral cost 20 guilders, twice the price of that of his son the year before. The grave was unmarked.

Three centuries later when the Westerkerk was restored, a skull, believed to be that of Holland's iconic painter, was found. The men and women from the world's media came in great excitement to the old burial place with their recorders and their cameras to see the remains revealed – only for the bones to crumble away to dust on exposure to the air. Much to everyone's relief, scientific analysis later revealed that the skull could not have been his. The fuss was for nothing. The last resting place of Rembrandt van Rijn remains unknown.

155

Acknowledgements

The kindness, patience and generosity of the experts in the field have been so overwhelming that I have begun to wonder if it might be generic.

I cannot thank them enough: Professor Dr. Ernst van de Wetering, Chairman of the Rembrandt Research Project, has been unstinting with his time, interest and daunting expertise. Dr. Bob van den Boogert, Curator of Museum Het Rembrandthuis, has not only given me help and encouragement but has, in addition, made my visits to Rembrandt's world a delight. At the National Gallery in London, David Bomford, Senior Conservator, answered all my queries, inconsequential though they might have seemed, with patience and kindness. And Manja Zeldenrust at the Rijksmuseum – I am fortunate that I met her early in my research and had the benefit of her guidance at the very beginning. All of them have taken the time to read those parts of my text on which I had consulted them, but, of course, any errors that might remain, despite their generous efforts, are mine alone and for these I apologise.

In addition to the benefits I have enjoyed from my conversations with the experts, I have derived insight, information and much else besides from many books on the subject, most especially the fascinating *Rembrandt: The Painter at Work* by Ernst van de Wetering, the marvellously evocative *Rembrandt's Eyes* by Simon Schama (which captivated me to the extent that I fear I may have inadvertently borrowed from him; if this is indeed the case, I acknowledge my debt to him with gratitude), *Rembrandt's House* by Anthony Bailey, *Rembrandt* by Christopher White, *Rembrandt and His Critics* by Seymour Slive, *Rembrandt, his life, his paintings* by Gary Schwartz, *The Rembrandt Documents* edited by Walter L. Strauss and Marion van der Meulen, not to mention the catalogue of Museum Het Rembrandthuis.

Also at the Rembrandthuis, I received valuable help and advice from Jaap van der Veen, Historian in charge of Research, and Aernout Hagen, Head of Education. Their guidance on etchings and drawings was invaluable.

Xanthe Brooke and Moira Lindsay at the Walker Art Gallery in Liverpool; Michael Howard at Manchester Metropolitan University; Kate Bell at the National Gallery in London, so many people, so much gratitude due:

Aukje Vergeest and Gijs Klunder for guidance, encouragement, and hospitality in Amsterdam, not to mention seeking out useful texts and translating them for me; David Hockney for bringing the Rembrandt drawings he so admires to my attention; Anita Tscherne and Ursula Wiart for help with German texts which needed not only translating but understanding; Helen Schlapak for interpreting elusive Dutch words; and, as ever, the marvellously helpful staff at the Hebden Bridge branch of Calderdale Library Service who went to endless trouble to find me books and papers from all over the place. The BBC for their arts programmes in general and in particular the makers of 'History of a Masterpiece'; also producer Veronica Thorne and researcher Abigail Adams; Rolf Harris not only for 'Rolf on Art' but also for his infectious enthusiasm. And all the Rembrandt scholars from whose books I have benefited.

As ever gratitude to all at THOTH Publishers: my editor Marja Jager, designer Ronald Boiten, translators Rob Kuitenbrouwer and Auke van den Berg, and the publisher, Kees van den Hoek.

Finally, an enormous collective thank you to Vijay Modgil, Mehmet Sen, Mary Birmingham, Veronica Allinson, Sue, Fran, Elaine and all the team; and most especially to Jo Dent and Jocelyn Gooch without whom (terrible cliché but nothing less will suffice) this book would never have been written.

Photo credits

The illustrations in this book come from the photographic services
of museums and private collectors, as noted in the captions. In
addition the following must be listed:

Bildarchiv Preussischer Kulturbesitz, Berlin: pp. 13 (left), 42 (right)

Sjaak Henselmans (Rembrandthuis, Amsterdam): pp. 38 (middle
and right), 82

Tim Koster (Instituut Collectie Nederland, Rijswijk/Amsterdam):
p. 27 (right)

NGS Picture Library, Edinburgh: p. 45 (below)

Photo ©The National Gallery London: p. 144

Photograph courtesy of the National Gallery of Ireland: p. 60

The Bridgeman Art Library, London: pp. 21 (bottom), 73 (right)

The Royal Collection ©2005 Her Majesty Queen Elisabeth II: p. 61
(right)

All the Rembrandt-etchings in this book have been scanned and
digitalized by Thoben Offset Nijmegen from the originals in
Museum Het Rembrandthuis in Amsterdam.

Colophon

© **2005** Shelley Rohde, Museum Het Rembrandthuis,
Amsterdam and THOTH Publishers, Nieuwe 's-Gravelandseweg 3,
1405 HH Bussum, The Netherlands
WWW.REMBRANDTHUIS.NL
WWW.THOTH.NL

Graphic design
Ronald Boiten and Irene Mesu, Amersfoort

Printed in Italy

ISBN 90 6868 399 3